1 MONTH OF
FREE
READING

at

www.ForgottenBooks.com

By purchasing this book you are
eligible for one month membership to
ForgottenBooks.com, giving you
unlimited access to our entire
collection of over 1,000,000 titles via
our web site and mobile apps.

To claim your free month visit:
www.forgottenbooks.com/free891044

ISBN 978-0-266-79807-1
PIBN 10891044

lished in
OLLYWOOD

ican Society of Cinematographers

The American CINEMATOGRAPHER

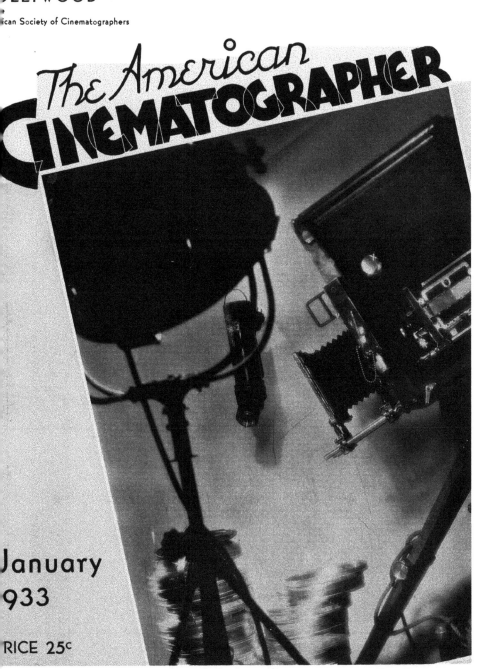

January
933

PRICE 25c

Wishing You
A Happier and More
Prosperous
New Year

❧

Wesley Smith -:- Simeon Aller

DuPont Film Manufacturing Company

AMERICAN CINEMATOGRAPHER

A Technical and Educational publication
of motion picture photography.

Published monthly by the
AMERICAN SOCIETY
OF CINEMATOGRAPHERS, INC.,
Suite 1222 Guaranty Building,
Hollywood, California.

Telephone Granite 4274.

JOHN ARNOLD, President, A. S. C.
GEORGE SCHNEIDERMAN, Treasurer, A. S. C.

Volume XIII JANUARY, 1933 Number 9

What to Read

The Staff

EDITOR
Charles J. VerHalen

TECHNICAL EDITOR
Emery Huse, A. S. C.

ASSOCIATE EDITOR
William Stull, A. S. C.

COVER AND ART
Dorothy Groton

**ADVISORY
EDITORIAL BOARD**
George Schneiderman, A. S. C.
Hatto Tappenbeck, A. S. C.
H. T. Cowling, A. S. C.
Dr. L. M. Dieterich, A. S. C.
Dr. C. E. K. Mees, A. S. C.
Dr. L. A. Jones, A. S. C.
Dr. W. B. Rayton, A. S. C.
Dr. Herbert Meyer, A. S. C.
Dr. V. B. Sease, A. S. C.

FOREIGN REPRESENTATIVES

Georges Benoit, % Louis Verande, 12 Rue
d'Aguessau, Paris 8e. John Dored, Riga,
Latvia. Herford Tynes Cowling, 311 Alex-
ander Street, Rochester, N. Y.

Neither the American Cinematographer nor
the American Society of Cinematograph-
ers is responsible for statements made by
authors. This magazine will not be re-
sponsible for unsolicited manuscripts.

Investigate this Great Advancement
in FILM PRINTING. The new Bell & Howell

AUTOMATIC SOUND PRINTER

BELL & HOWELL Company continues its great pioneering tradition! The new B & H Automatic Printer, developed at a tremendous cost over a period of three years, introduces the greatest advance in many years in laboratory practice and printing. While designed for high quantity production, it gives at the same time a vastly finer control of print density and quality than has been hitherto possible. The light control steps and adjustments have been calibrated on a positive sensitometric basis, thereby enabling scientific densitometric control to be maintained with maximum ease and certainty. Guesswork is completely eliminated. Sound and picture are printed at one operation under fully automatic interlocking control. Film notches are completely eliminated. Density is controlled by traveling matte. The machine is ruggedly built, yet constructed to a precision of adjustment at least equal to, if not exceeding, that of a fine watch. Every requirement in modern sound film production has been anticipated. Write today for full and complete details on this modern, scientific method of making the finest prints in large quantities.

✦ How to Buy a Personal ✦

MOVIE PROJECTOR

LESSON one in buying personal movie equipment is: Get down to fundamentals! List every fundamental requirement for perfect motion picture projection. Check all features of the Filmo Projector against this list. No matter how many requirements, or how exacting, the Filmo Projector will best answer every demand for perfect movies. Check these points:

1 *Picture Quality*—Filmo movies are brilliant, steady and flickerless, owing to exclusive 9 to 1 shuttle movement, powerful direct lighting.
2 *Dependability*—The Filmo Projector *has proved* that it will run for years with constant dependability.
3 *Film Safety*—Your film is safe in a Filmo. No friction on the film surface—only a slight pressure along the edges. Negligible wear in sprocket holes.
4 *Cost*—You can buy a Filmo Projector for as little as $135. You pay no more for Filmo's superior quality and superior pictures.
5 *Guarantee*—Behind these filmo fundamentals is a three-year guarantee against any defects in materials or workmanship, backed by Bell & Howell, world's largest producer of professional cinemachinery and pioneer in 16 mm. movie equipment.

So when you buy a movie projector, get down to fundamentals and apply every test you can think of. A Filmo Projector is the outstanding answer. See your dealer, or write today for complete information on Filmo Projectors.

BELL & HOWELL

FILMO

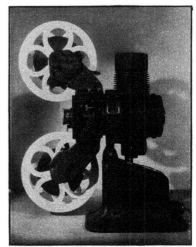

The famous Filmo JL Projector, 100 per cent gear driven, with automatic power rewind, 400 watt lamp, aero-type cooling, pilot light, and a score of other refinements that remove all fuss and bother from the showing of 16 mm. movies. Can be used in living room or theater auditorium. With case, $298.

1848 Larchmont Ave., Chicago; 11 West 42nd St., New York; 716 North La Brea Ave.,Hollywood; 320 Regent St., London (B & H Co., Ltd.)Est. 1907.

PROFESSIONAL RESULTS WITH AMATEUR EASE

THE AMERICAN SOCIETY OF CINEMATOGRAPHERS was founded in 1918 for the purpose of bringing into closer confederation and cooperation all those leaders in the cinematographic art and science whose aim is and ever will be to strive for pre-eminence in artistic perfection and technical mastery of this art and science. Its purpose is to further the artistic and scientific advancement of the cinema and its allied crafts through unceasing research and experimentation as well as through bringing the artists and the scientists of cinematography into more intimate fellowship. To this end, its membership is composed of the outstanding cinematographers of the world, with Associate and Honorary memberships bestowed upon those who, though not active cinematographers, are engaged none the less in kindred pursuits, and who have, by their achievements, contributed outstandingly to the progress of cinematography as an Art or as a Science. To further these lofty aims, and to fittingly chronicle the progress of cinematography, the Society's publication, The American Cinematographer, is dedicated.

AMERICAN SOCIETY OF CINEMATOGRAPHERS

OFFICERS

JOHN ARNOLD	President
ARTHUR MILLER	First Vice-President
FRANK GOOD	Second Vice-President
ELMER DYER	Third Vice-President
GEORGE SCHNEIDERMAN	Treasurer
WILLIAM STULL	Secretary

BOARD OF GOVERNORS

John Arnold	Fred Jackman
John W. Boyle	Victor Milner
Arthur Miller	Hal Mohr
Daniel B. Clark	George Schneiderman
Elmer Dyer	John F. Seitz
Arthur Edeson	William Stull
Frank Good	Ned Van Buren
	Alfred Gilks

PAST PRESIDENTS

Philip E. Rosen	Hal Mohr
Gaetano Gaudio	Homer Scott
James Van Trees	John F. Seitz
John W. Boyle	Daniel B. Clark
Fred W. Jackman	Arthur Webb, General Counsel

HONORARY MEMBER

Mr. Albert S. Howell, Chicago

ASSOCIATE MEMBERS

Mr. Emery Huse	Dr. Loyd A. Jones
Mr. Fred Gage	Dr. V. B. Sease
Dr. W. B. Rayton	Dr. L. M. Dieterich
Dr. C. E. K. Mees	Dr. J. S. Watson, Jr.
	Dr. Herbert Meyer

PUBLIC RELATIONS COMMITTEE

John Arnold	Edwin L. Dyer
Joseph Dubray	Ariel Varges
Georges Benoit	Charles Bell
Harold Sintzenich	Frank C. Zucker
H. T. Cowling	John Dored

PRODUCTION COMMITTEE
Daniel B. Clark, Chairman.

MEMBERSHIP COMMITTEE
Hal Rosson, Chairman

ENTERTAINMENT COMMITTEE
Frank B. Good, Chairman.

WELFARE AND RELIEF COMMITTEE
Arthur Miller, Chairman.

EXHIBITION COMMITTEE
Arthur Miller, Chairman, Karl Struss, Daniel B. Clark.

RESEARCH COMMITTEE
Chairman, John F. Seitz
Dr. L. M. Dieterich
Hal Rosson

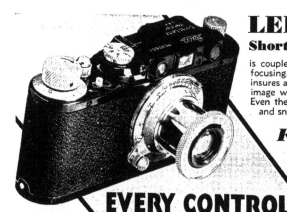
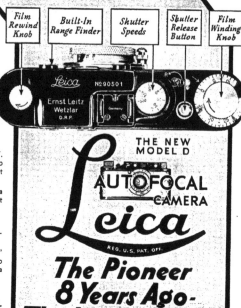

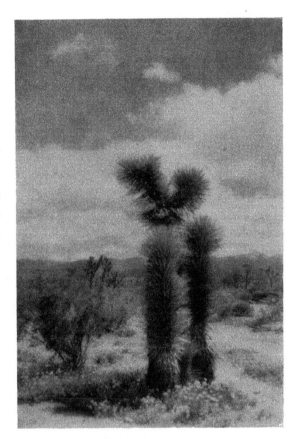

DESERT
STUDIES

by
Ned Van Buren
A.S.C.

Co-Operation

CO-OPERATION between the Art Director and the Cinematographer is an important factor in the success of any picture—but it is absolutely vital in the instance of an Independent production. There, every penny must count—and do double duty if possible. To be successful, especially when released as part of a major distributor's program, the independently made feature must have fully as much production value as any major-studio product—yet it must be made for a relatively modest cost.

Very little can be saved on either the cast or the production staff, so the major economies must be effected through reduction of the items charged to studio overhead and set-construction. The amount saved through the Independent producer's elimination of the huge overhead charges that face the studio producer is, of course, almost arbitrarily fixed; but the amounts that can be saved in set-construction are capable of almost infinite variation. The burden of effecting the maximum economy in this direction rests with the Art Director and the Cinematographer. It is not, and cannot be, a one-man job, for either one can nullify the other's efforts in this direction. But if they work together, they can accomplish truly amazing results.

The Independent producer's Art Director is from the start faced with a basically different problem from that of the major-studio's Art Department. The latter almost always has his choice of either revamping a standing set, or constructing a completely new one. As a rule, he will do the latter eight times out of ten. The Art Director for the Independent producer, on the other hand, having a relatively small budget for the sets on any given production, must almost invariably remodel existing sets to suit his needs. He must do this in such a way that the sets are not recognizable as re-vamps; they must look new, and fit the needs of the story. Moreover, he may not spend too much money on their remaking.

The Cinematographer can make or mar the Art Director's work in this, for he can enhance the appearance of the sets with his lighting and with his selection of camera set-ups—or he can arrange his lightings in a routined, slipshod manner, and cheapen even the best sets. He can even force additional construction if he is not sure of the set-ups that will be needed.

I have always been fortunate in having cameramen who were willing to cooperate with me assigned to photograph the pictures in which my sets have been used. Most recently, in the four pictures lately completed by the Charles R. Rogers Company, for Paramount release—"70,00 Witnesses", "Madison Square Garden", "The Devil Is Driving", and "Billion Dollar Scandal"—I have been fortunate in being associated with two of the most outstanding co-operative cinematographers in the industry: Henry Sharp, A.S.C., and Charles Stumar, A.S.C. Both of these men have the unusual faculty of being equally proficient with big, expensive productions or with "quickies". They are eager to co-operate with the Art Director from start to finish: they realize the importance of co-operation, and do everything in their power to assure that the sets reach the screen as perfectly as possible. Their co-operation and ability have saved thousands of dollars on every production we have made.

To be specific: on the most recent of these films, we managed to provide the necessary settings for a figure $17,000 below what new construction would have cost. This was done partly in the Art Department, by carefully revamping a number of existing sets, and partly on the set through the careful and expert lighting of the Cinematographer.

The illustrations show one of the ways in which the co-operation of the Cinematographer can make or break the Art Director's work. Both show the same set; one

has been carelessly lit, the other, carefully lit, by Charles Stumar, A.S.C. In the first example, Mr. Stumar has tried to do everything wrong: he has lit the set in too high a key, made no attempt to separate the different planes through lighting, no attempt to model the physical characteristics of the set, and, in fact, robbed it of all of the richness that such a set should have. In the second example, he has lit the sets as he did when actually photographing the picture: he has used a decidedly lower key of lighting, which, in itself adds to the richness of the set. Moreover, he has used a more diffused lighting throughout, keeping the direct beams from the walls almost entirely. He has lit the set so that the different planes are visually separated—through contrast of dark planes against lighter ones—and in general treated the set so that it has a definite atmosphere of quality. The first instance shows the set lit in the routine manner that many capable cameramen would employ: such lighting is not bad in itself—but it is bad in that it does not show the set off to its best advantage, or coincide with the dramatic mood of the story.

In the same picture, we were able to use the same set again, slightly remodelled, as a Congressional inquiry-chamber. My part of it was relatively simple—removing a wall here, changing an angle there, substituting panelled flats for the bookcases, adding columns, etc.: but the really important work was that of the cinematographer. If he had seen fit to light the set the second time exactly as he had before, all of the work done in revamping and redressing the set would have been in vain. As it was, Mr. Stumar's skill saved the day. He lit the set in a different key and a different mood. He used different camera-set-ups and angles, showing the set from different viewpoints, bringing out entirely different aspects of the set. I do not believe that one person in ten could spot the set as one that had been doubled—even if he knew

This is the same set as shown on the opposite page with a few changes. It saved the producer many thousands of dollars in production.

Saved
Us $17,000

by

Harrison Wiley
Art Director,
Charles R. Rogers
Productions

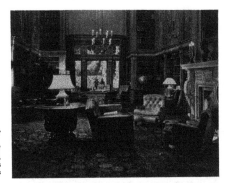

Improper lighting is glaringly demonstrated in this picture. It loses not only photographic values, but also production values.

that we had done so. Members of the company, in fact, have seen the completed picture, and failed to recognize the two sets as one.

Had Mr. Stumar not been willing to co-operate with us in this, or had he been unable to readjust his light-

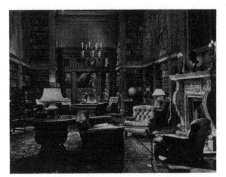

The same set as above properly lighted so as to bring out all the photographic as well as production values.

ing as he did, we would have been forced to build a new set.

Still another important consideration is the painting of a set. If the Art Director and the Cinematographer do not understand each other thoroughly, revamped sets often have to be repainted—sometimes even after having been repainted once. If the Art Director, for instance, does not know what visual effects the Cinematographer is planning to achieve, he can easily have the set painted the wrong color, or the wrong way. If the Cinematographer does not co-operate with the designer, this situation cannot be helped. If, on the other hand, he does not know how to light his set properly, he can often force us to repaint a set anyhow. Yet it has been proven time and again that a great deal can be done in painting a set with light: the illustrations show this very clearly. The capable cinematographer can frequently use his lighting to avoid the expense of repainting a set—even one that really needs repainting.

Here, by the way, I must pause and pay tribute to the ingenuity of the Paramount Studio Art and Camera Departments. The respective heads of these departments—Hans Dreier and Virgil Miller—have evolved a systematized range of paints and colors so that not only can the shade for any given set or part of a set be specified by number, but certain shades can be obtained which, though giving a pleasing contrast visually, photograph identically. This is often important when working with certain directors and players, upon whom the psychological effect of the color contrast is considerable, but where such contrasts would be undesirable in the finished picture.

The co-operation of the Cinematographer is of great value in the painting of backings and forced-perspective backgrounds. Very often I have had men like Sharp come to me with suggestions for painting such backgrounds, saying, "Now, if you can paint this so, I can light it better." This co-operation is vital, for unless these important portions of a set photograph naturally, the impression built up by the rest of the set is bound to suffer.

If the Cinematographer can be given an opportunity to become familiar with the script before production, he and the Art Director can in many instances save a great deal. If you can be certain that only certain angles will be used, you need not repaint or revamp your set beyond those angles. If you can be certain, for instance, that some certain shots will not be reversed, you need not build wide walls or flats to protect the company on those possible reverse-shots. If you can be certain that the camera will be used at only a certain height, you can often save in both construction and painting which would otherwise be required. If you can be sure in advance just where dolly shots will be used, and where they will not be, you can save again. If you can be sure that your sets will be lit understandingly, you can often save a paint-job.

And with all due respect to Scenarist and Director, it is only the Cinematographer who can give you positive, authoritative information on such points as these. Therefore I am heartily in accord with the policy of calling in the Cinematographer farther before the actual start of shooting than is now the rule. Only thus can one reap the full benefits of the co-operation between the Cinematographer and the Art Director. These two individuals must co-operate now as never before, for in the major studios and the independent units alike, it is their co-operation that can effect some of the most urgently needed economies of the day.

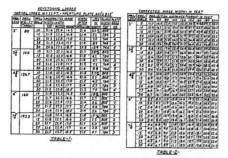

Projection

As soon as we project at an angle from horizontal, the top of the screen is nearer the projector lens than the bottom. Obviously the width of the picture on the screen is greater at the bottom than at the top, as shown by the dotted lines to the right of Fig. 1.

The remedy adopted is to use an aperture plate which is narrower at the top than at the bottom.

Figures 2 and 3, facilitate convenient determination of the various screen and aperture plate dimensions for different conditions of projection angle, focal length of lens and throw.

The average screen used in the majority of theatres is somewhere about 16 ft. x 22 ft. in size. In order to illustrate the conditions involved in average practice, they are tabulated in Table No. 1.

Table 1 is worth serious study and particular attention is called to the columns giving the percentage losses for keystoning correction. These losses can also be read directly from Fig. 2 if desired. For example, taking the 3 inch lens at a 20 degree projection angle, read from the intersection of the 3 inch and 20 degree lines down to the figures at the bottom. This constant "C" is a multiplier to be used with the full plate width dimension to obtain the top width of the plate used in the keystone correction. In the instance given "C" reads .93 and indicates a 7 percent loss.

It will be seen that the percentage keystoning loss varies from about 2 percent to 10 percent. The loss, in percentage, increases with increase of projection angle and also increases as the focal length of the lens decreases. On the average the loss will run about 6 percent. This means that about one-twentieth of the picture width at the bottom is sacrificed—it's not much, but it is lost. What it really amounts to is that there is an average distortion of about this 6 percent.

A doorway, for example, would be 6 percent wider at the bottom than at the top. The bottom of the door would be nearer the sides of the picture because the sides have

THE establishment of the new standard camera and projector apertures is fresh in everyone's mind, so that the importance of the picture area on the film, in relation to the projector aperture, is fully recognized.

Theatre projection conditions demand the otherwise undesirable compromise of projecting the picture at an angle above the horizontal—departing from the right angle relationship with respect to the screen.

The focal length of lens used together with the determined angle of projection become reciprocal functions for establishing the degree and character of the projected picture distortion.

This Projection Keystoning is another condition which influences the effectiveness of the cameraman's composition on the screen. Not only does this affect the relative frame width at the top and bottom of the picture, but it also affects the 3:4 proportion of the composition. Fig. 1 illustrates the effect graphically and shows how the shape of the aperture plate is altered to compensate for the distortion caused by projecting at an angle.

As will readily be appreciated, the amount of distortion increases with increase in angle of Projection, the Projection distance, focal length of lens, and the size of the screen picture. The greater the distortion, the greater the amount of the keystoning of the aperture plate that is necessary and consequently, the greater the masking of the picture area when it is thus "corrected."

In this article, we propose to analyze some of these factors and determine the extent to which they influence the cameraman's "lining up" and composition of a scene.

First of all, it is desirable to analyze Fig. 1 which illustrates the cause of and the compromise for "keystoning."

Graph for determining projection angle and constant "A" for different conditions of height and length of throw.

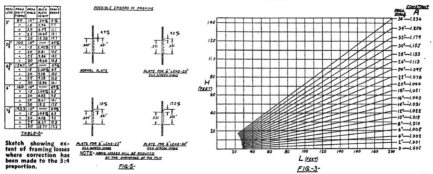

Sketch showing extent of framing losses where correction has been made to the 3:4 proportion.

Keystoning from Cameraman's Viewpoint

by

R. Fawn Mitchell

Manager Technical Service
Bell & Howell Co.

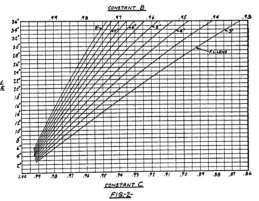

Graph for conveniently determining correction constants for any condition of projection angle and focal length of lens.

been masked to trim the screen picture. Usually, these are not noticeable except perhaps when long vertical lines, columns, etc., occur near the edges of the picture. Therefore this condition should be avoided whenever possible. Other than this, the average keystoning correction is not especially serious.

Table No. 2 in conjunction with Fig. 3 covers the corrected screen width for different conditions of projection angle and lens.

We have seen what keystoning does to the cameraman's composition so we will now investigate what a correction for the 3 x 4 proportion would involve. We find that the loss in picture height varies from about 1½ percent to 16 percent. For larger screen pictures and for longer throws, the loss will average greater than in the smaller theatres. We can assume an average loss of at least 10 percent but running nearer 15 percent for metropolitan theatres. Furthermore, as shown in Fig. 5, and the last column in Table 3, the framing error is a most serious factor.

As is well recognized, the top and bottom margins of a picture are much more important than the side margins.

Any attempt to cut the picture height will run the risk of cutting either or both of the head or feet of the players, or at least reducing the head room.

This is the condition the new standard aperture was mainly designed to avoid and is the reason why so much stress is placed on projector apertures being maintained at the full .600 inch height. This is especially important in view of the recommendation that the picture be composed and framed from the top.

It is felt that the extra 3 x 4 proportion correction is not only unnecessary but distinctly inadvisable. Few if any normal theatre patrons are able to detect a slight departure from EXACT 3 x 4 screen dimensions. They do, however, readily detect insufficient head room in a scene and resent it if the condition is bad enough to cut off the heads or feet of the subject.

Fig. 4 represents a suggested series of standard projector

Continued on Page 45

Sketch illustrating the cause of picture distortion due to projection at an angle.
At left—aperture plate corrected for keystoning.
At right—screen picture obtained with corrected aperture plate.
WT—Width of corrected aperture plate, at top.
L—Length of throw.
H—Height of projection lens above center of screen.
PL—Actual length of projection.
SH—Actual height of screen picture.
SW—Actual width of screen picture, after correction.

Sketch showing relative correction given by the proposed series of five aperture plates.

$$A = \text{CONSTANT FOR } PL \text{ AND } SH$$
$$B = \text{CONSTANT FOR } SW$$
$$C = \text{CONSTANT FOR } WT$$
$$PL = \text{PROJECTION LENGTH (THROW)} = L \times A$$
$$SH = \text{SCREEN HEIGHT} = \text{NORMAL SCREEN HEIGHT} \times A$$
$$SW = \text{SCREEN WIDTH} = \text{NORMAL SCREEN WIDTH} \times B$$
$$WT = \text{APERTURE TOP WIDTH} = \text{NORMAL WIDTH} \times C$$

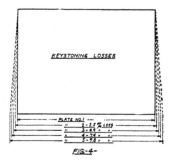

KEYSTONING LOSSES

PLATE NO. 1 --- 1 - 1.5 % LOSS
" 2 - 4 " "
" 3 - 4.9 " "
" 4 - 7.4 " "
" 5 - 7.6 " "

FIG-4-

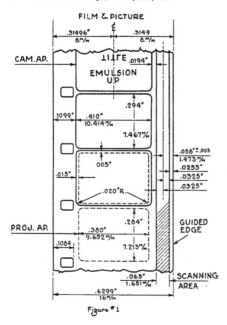

Figure #1

Solving

THE problems encountered in recording a satisfactory, or, perhaps more appropriately a commercial quality sound track have retarded the introduction of 16 mm. sound films to the public. These problems have been carefully studied and a number of solutions presented by various organizations interested in the 16 mm. field. One of the most perplexing and perhaps the most difficult of obtaining agreement regarding its solution pertains to the adoption of suitable film dimension standards. In order to avoid the confusion created in the 35 mm. field by lack of standardization during the introduction of sound in the theatre, it is advisable to adopt the proper standards while the industry is yet in its infancy. A general agreement must be reached sometime if the industry is to grow and, unless the consumer can be assured that he will not have to bear the expense of a change in standards at a later date, the expansion of the 16 mm. motion picture field will be severely retarded.

Most projection equipment and film manufacturers agree, however, that the 16 mm. film should be retained and that its speed of travel for sound film should be 36 feet per minute. Film economy, existing manufacturing equipment and the large number of silent machines now in use are partly responsible for this agreement. As will be recognized at once, this film speed is 40 percent of the speed of 35 mm. film and involves a reduction ratio of 1 to 0.4. This reduction ratio has been used on silent films and it is desirable to maintain this ratio for interchangeability. While the advantages of 16 mm. film are apparent, a detailed discussion of the problems involved in recording sound on this narrow film are essential to a clear understanding of the processes and practices forming the standards adopted for use in making 16 mm. sound-on-film prints.

It should be understood that aside from the purely technical details there are certain practical limitations and

practices that require serious consideration if the consumer is to obtain maximum satisfaction from the operation of his equipment. There is a rapidly growing tendency in the 16 mm. field to increase the picture size and brilliancy. As higher powered lamps are made available, larger pictures become more feasible. At the same time, an increasing demand is made upon the lamp manufacturer and projector producer to project a brighter picture. Then too, the increasing use of 16 mm. projectors in schools, churches and small auditoriums makes a larger picture necessary. At the present time, 16 mm. projectors are required to project a 6 x 8 foot picture, in many cases in a partially lighted room, whereas formerly a 30 x 40 inch or perhaps a 36 x 48 inch picture was considered large enough. It is also significant that the light intensity on the screen, formerly obtained with the smaller picture, borders on the lower acceptable limit for the larger picture now demanded. It should be apparent that with a given intensity at the picture aperture the screen intensity will decrease as the picture size is increased. With these two factors operating in opposite directions it becomes more difficult to satisfy the demand for larger and brighter pictures.

Another item which must be considered from the consumer's viewpoint is that of volume range, or sound output as it is sometimes called. In churches, schools, auditoriums and sales rooms it is often necessary to have sufficient volume to entertain an audience of two or three hundred people. In the home, a much lower volume level is required and the problem is not so serious in this field.

With the above mentioned conditions to be met is combined the feature of portability. Especially in the industrial and educational fields, portability is a major factor. This means that the projection equipment must be as small as possible in physical dimensions and its weight reduced to a minimum—and these in view of the demand for larger and brighter pictures and a volume output comparable with most of the portable 35 mm. sound-on-film projectors now on the market. In order to combine all these features, it is necessary that the film itself be worked to the maximum limit from both the sound and picture standpoint.

One of the major items affecting the projected picture is the image size on the film. After carefully considering all the items affecting the projected picture, it was decided to standardize on the image and aperture sizes previously adopted for silent films. In endeavoring to arrive at a conclusion, items such as picture quality, heat dissipation, emulsion grain, picture size, optical systems, screen brilliancy, interchangeability with silent films and cost of making prints were considered. In addition to the advantages of a larger picture, the dimension of the film shown in Figure 1 offers advantages in recording the sound track that will be discussed later.

Figure 2 shows the dimensional standards adopted for picture and aperture sizes for 16 mm. silent films. Figure 1 shows the dimensions of a 16 mm. film on which a sound track has been placed. Comparing the dimensions of Figure 2 with those of Figure 1, it will be found that the picture and aperture sizes and their locations on the sound film are identical with those of the silent film. Thus it is evident that no change is necessary in the picture size or location for the sound film. This picture then conforms to the standard for silent film and is interchangeable with it. Of

Sound on 16 mm. Film

by

B. L. Hubbard

With R.C.A.-Victor Co., Inc.

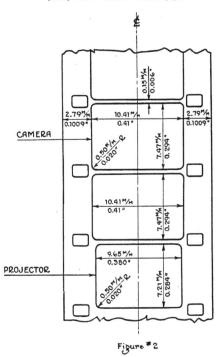

CAMERA

PROJECTOR

Figure #2

the several methods tried the arrangement shown in Figure 1 is the only one maintaining a standard picture size on 16 mm. film and this arrangement offers several advantages which make it superior to any other type of film. As stated above, one of the major advantages is that of a wider or full-size picture. Maintaining the standard aperture and picture sizes makes it possible to project silent pictures on sound-on-film projectors without any adjustments to the sound projector aperture; whereas, any of the other proposed arrangements made it necessary to reduce the aperture size for the sound films and provide an adjustment for increasing its size when projecting silent films made on amateur cameras or subjects obtained from silent film libraries. The elimination of any such adjusting device is a decided advantage in favor of the standard aperture and picture size in projector design and construction. Also, any reduction in picture area requires increased magnification to obtain the same screen image size resulting from the use of the larger film image area with equivalent lenses and projection distances. The increased magnification is not a problem in itself, but as the magnification is increased the emulsion grain size becomes more of a factor in picture quality. While finer grain emulsions are available, they are not standard emulsions for 16 mm. film and would materially increase the cost of the raw stock, if required at this time. In connection with this item it is well to consider the viewpoint of the leading manufacturer of 16 mm. film, because the engineers and film experts of this company have declared themselves opposed to the adoption of any standard requiring a picture area and projector aperture smaller than that adopted for silent films. Furthermore, it is desirable to consider, and make provision for, a 16 mm. sound-on-film camera. Sound films must be taken and projected at 24 frames per second instead of the 12 or 16 frames per second film speed used for silent pictures. It is, therefore, desirable to have as large a picture area as possible in order to overcome the handicap of increased film speed and to maintain the present picture quality of silent films.

Also, the use of the standard picture size permits the most efficient optical system design. If a smaller picture size were used for the sound films, the light transmitted to the screen would be less than that of the larger picture because the optical system would be required to cover the standard aperture for silent films and, hence, the light masked off when reducing the aperture size for a smaller than standard picture would be completely lost. As the higher wattage lamps are made available the amount of

light, and hence the heat, transmitted to the film at the aperture increases. In order to keep the heat per unit area as low as possible it is necessary to keep the area of the film exposed to the light as large as possible. In view of the fact that the public is demanding larger and brighter pictures, it is evident that the most efficient and plausible way of satisfying this demand is to use as large a picture area as possible and design the optical system to efficiently cover that area only. Consequently, the retention of the standard picture size is of major importance in the solution of the problems pertaining to the use of sound films; and, it should be evident that the standard shown in Figure 1 permits the fulfillment of the demands for larger and brighter pictures in the best technical and practical manner.

As may be seen in Figure 1, one row of sprocket holes has been omitted and the space used for the sound track. This alternative was decided upon after an extensive study of sound quality and volume output from 16 mm. film. As pointed out by Dr. E. D. Cook in the S.M.P.E. Journal for June 1930, the "quantity of light falling on the photoelectric cell is proportional to the product of the light intensity and the area of the reproducing aperture uncovered by the unexposed part of the film as it passes the aperture." Also Mr. R. D. Stryker and Mr. Donald Foster in their articles in the November 1930 and November 1931 issues, respectively, of the same journal show that this is a fundamental fact. Then, it is obvious that with a given fixed aperture width the quantity of light falling on the photoelectric cell is proportional to the length of the reproducer aperture since this quantity will vary with the area. The reproducer aperture length bears a fixed relation to the

sound track width; hence, an increase in aperture area obtained by an increase in its length means a proportionate increase in sound track width if the record is modulated to the same per cent amplitude. Since the output of the reproducer is a function of the quantity of light on the photoelectric cell and the amplification, it is apparent that with a fixed gain level the volume range of the equipment increases as the quantity of light on the cell increases and, therefore, as the width of the sound track increases.

There are also other factors affecting the output of the equipment which should be considered. Where noiseless or ground noise reducing equipment is used in recording, there is a practical limit to which the ground noise eliminating mechanism can be adjusted. If the ground noise reducing mechanism is adjusted to the practical physical limit for maximum ground noise reduction on the 35 mm. track, then there can be no proportionate ground noise reduction for decreased track widths. On the 16 mm. films reduced from 35 mm. film the ratio of ground noise to modulated signal should be about the same for both prints; but, in the case of a 16 mm. sound-on-film camera and other equipments making original recordings on 16 mm. film, ground noise hiss cannot be reduced below the nominal value obtained on the 35 mm. print because of the practical limits of the adjustments of the noise reducing mechanism. In view of this condition it can be seen that on 16 mm. original recordings a higher ground noise to signal ratio may be expected for reduced sound track widths.

Because of these difficulties, it is advisable to use as wide a sound track as possible on 16 mm. film. Detailed examination of the sound track dimensions shown in Figure 1 will reveal the fact that this track width is slightly less than the sound track width used on 35 mm. film. Therefore, the ground noise to signal ratio for this film closely approximates the value obtained on 35 mm. film; and furthermore, it is possible with this track width to maintain this value on both 16 mm. films reduced from 35 mm. prints and original 16 mm. recordings. As was shown previously, the wider the sound track the greater the volume output; and, it has been determined that this width track is the most satisfactory to simplify the amplification problems and facilitate the economic manufacture of small portable amplifiers with uniform characteristics and volume ranges sufficient to satisfy the requirements of schools, churches and small auditoriums.

The method of commercially making 16 mm. release prints for sound-on-film projectors has been one of the most difficult problems to solve. Direct optical reduction of both the sound track and picture on a continuous printer would result in a duplicate of the 35 mm. print reduced by a ratio of 1 to 0.4. This would produce a narrow sound track and picture, and introduce losses of serious magnitude. The slower film speed of the 16 mm. print reduces the photographic quality of the sound track to 40 percent of that of the 35 mm. print; that is, 10,000 cycles on the 35 mm. print is photographically equivalent to only 4,000 cycles on the 16 mm. print. It is evident, therefore, that photographic limitations handicap the 16 mm. print in so far as frequency response is concerned and the further we extend this frequency range the greater this handicap becomes. In addition to the photographic losses, there would be printing and processing losses obviously incurred by the 16 mm. print that are of equal or probably greater magnitude than those found on 35 mm. prints from the same negative. These losses are in the form of filling in or fogging between peaks and reduce the total volume or signal output from the print. Obviously then, unless some correction were made in the 35 mm. negative, the quality of the resulting 16 mm. sound track made by direct optical reduction would be considerably less than that of the 35 mm. print because compensation for these losses could not be made in the 16 mm. print. To improve this condition, compensation for these losses is necessary in order to improve the quality of the 16 mm. sound track. The most satisfactory method of obtaining the desired compensation is by a re-recording process. Electrical compensation for printing and reproducer losses is added in the re-recorder circuit and the resulting 16 mm. track is then of higher quality than is obtainable by any reduction printing process. In fact, it is possible by this method to obtain a 16 mm. sound track that is superior to the original 35 mm. recording. In support of the flexibility and economics of this process more than 60 per cent of the pictures now being produced are re-recorded. Since the producers find it advisable to re-record in their initial make-up to facilitate production of satisfactory prints, it is evident that a similar process will prove equally flexible and desirable in the production of 16 mm. prints. The production of the 16 mm. prints is much the same as that of 35 mm. release prints. A 16 mm. sound negative is made by re-recording from a 35 mm. print. Monitoring, compensation and editing are accomplished in the re-recorder and the resulting 16 mm. sound negative is used for continuous contact printing to 16 mm. release prints. This method simplifies the production of high quality 16 mm. prints and makes use of some of the equipment now in film processing laboratories.

Many of the film processing laboratories have 16 mm. continuous contact printers which can be converted to continuous sound printers at a very nominal cost. Two methods of obtaining the picture size shown in Figure 1 have been suggested and are now in use where 16 mm. sound prints are being made. One is by step printing from a 35 mm. negative directly to the 16 mm. positive release print. The other is by step printing from a 35 mm. master positive to a 16 mm. negative and contact printing from the 16 mm. negative to the release prints. In both of these methods it is proposed to print the sound from the re-recorded 16 mm. sound negative to the 16 mm. release print. In the latter case, the sound track and picture can be on the same negative, whereas in the first case there is no 16 mm. picture negative. In either case, the picture size proposed can be obtained by a slight change of optical reduction ratio and the shifting of the 16 mm. printer head so the center-line of the 35 mm. picture coincides with the center-line of the 16 mm. film and picture. It is possible to make both these adjustments on the step printers made by one of the leading motion picture equipment manufacturers. There are a number of these printers, in use by the film processing laboratories that make 16 mm. silent films, which can be converted at a nominal cost and used for making sound-on-film prints according to the standard shown in Figure 1. If any other standard is used, this existing equipment must be supplemented by new equipment. Thus no new capital investment is necessary to the laboratories to make 16 mm. prints by this re-recording method. Certainly, a direct printing process will not permit the flexibility or resultant quality obtained from the process proposed for production of the film using only the one row of sprocket holes.

After an extensive study of life of films run on 16 mm. silent projectors used by the public, it was decided to omit one row of sprocket holes and use that space for the sound track. As may be expected, the greatest film or sprocket

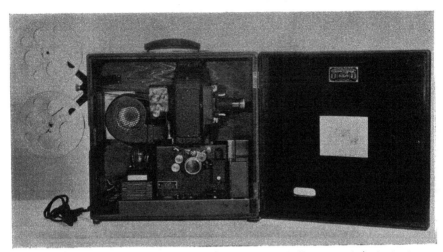

One of the first of the 16 mm. sound projectors to be developed, using the new recommended standard of sound on 16 mm. film.

hole wear and abuse occurs at the picture gate because of the tremendous acceleration imparted to the film during the pull-down portion of the cycle. This acceleration is applied by a claw; and, the impact of this claw on the edge of the sprocket hole causes wear on the film. Curiously enough, however, two of the best known and most extensively used makes of 16 mm. projectors have this pull-down action on ONE ROW OF SPROCKET HOLES only. One of these two makes is cited by the trade as a standard to which all other 16 mm. projectors are compared, and, it is interesting to note that for years the claw on this make of projector has operated on one row of holes only, regardless of the fact that the film has two rows of sprocket holes. A third well-known make has a claw engaging both rows of holes but the manufacturers of this equipment have recently indicated a preference for a film with only one row of sprocket holes. Perfect registration of both rows of holes by a claw engaging both sides of the film is highly improbable because too close manufacturing tolerances are required for such precision parts to permit economical manufacture. Also, it is very probable that the claw will become bent or deformed enough while in use to prevent its engaging the edges of the holes on both sides of the film at the same instant. Accordingly, one row of holes will carry the load until sufficiently deformed to permit the claw to engage the edges of the holes on the other side of the film. After once having deformed the edge engaged by the claw, the sprocket hole tears out very easily and is, of course, useless. The load is thus transferred to the other row of holes and under these conditions the two rows of holes do not offer the additional safety factor anticipated by a preliminary analysis. In fact, on those projectors using a single claw pull-down there is no advantage because the film cannot be pulled through the picture gate if the holes are torn out on the claw side regardless of whether there are one or two rows of sprocket holes. The practicability of engaging the claw with only one row of holes has been

successfully demonstrated by the operation of more than one hundred thousand silent projectors in the hands of home movie fans. Obviously, then, the omission of one row of holes will not materially reduce the life of the film. Consequently the organizations advocating the adoption of a standard as shown in Figure 1 agree that the apprehension expressed by the opponents of a standard with a single row of sprocket holes is not warranted.

Summarizing these points, it is found that a film standard such as shown in Figure 1 offers: (1) a sound track with the highest relative output and lowest ground noise to signal ratio possible on 16 mm. film, (2) the largest possible picture with greatest screen brilliancy, (3) interchangeability with silent films without adjustment of the projector picture aperture, (4) the most economic and efficient use of the light available for picture projection, (5) greatest volume range for any given amplifier gain, (6) most flexible method of production of 16 mm. prints, (7) provision for compensation of film and printing losses in the sound track, and (8) use of existing equipment in the laboratories. These advantages are obtained by the omission of one row of sprocket holes, and it has been demonstrated by silent projector owners that this is not a detrimental feature.

As evidence of the trend at the present time, the September 1932 issue of ELECTRONICS has an article entitled "Standardized 16 mm. Sound-on-Film," which reads in part as follows: "To clarify the 16 mm. sound-on-film situation, the RCA Victor Company, Bell & Howell, and the International Projector Company, leading manufacturers of sound reproducing equipment, and the Eastman Kodak Company, the largest producer of sixteen millimeter film, have individually decided to maintain the present standard size 16 mm. film in the production of sound-on-film motion pictures by eliminating one of the two rows of sprocket holes and by utilizing the space thus acquired for the sound track."

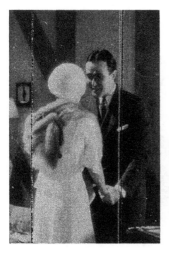

Enlargement of a scratched and abraded 35 mm. negative. Compare this with same picture at bottom of page, which is enlargement from same negative after being "frosted."

"Frosting" Negative Eliminates Scratches

SCRATCHES, abrasions and cinch marks can now be eliminated from the polished side of the negative. This is not accomplished through the channels with which the industry has been familiar for many years, but by a process which peculiarly has been in operation in Europe for the past 15 years.

The methods ordinarily used for negatives which have been marred in some manner or other was to clean and polish by various methods to remove the dirt and matter which had accumulated in the scratches. However, it had been found that in view of the fact that the depression was not removed, the handling of the negative soon filled these abrasions with matter and they again showed white on the positive when put through the printing process.

The method in operation in Europe and especially in Germany while new to America is said to have been in operation in that country for about fifteen years.

The manner in which it is accomplished by what the Europeans term MATTEING, but which when finished gives the polished side of the negative celluloid a "frosted" appearance is by remoulding or recasting the polished side of the film. This is done by means of a machine which the Europeans have perfected and produces small abrasions on the polished surface that are 20 times smaller than ground glass.

This frosting method does not add anything foreign to the film . . . in fact it adds nothing, merely breaks the polished surface into minute abrasions that have a tendency to fill in and eliminate all scratches or other depressions that may have accumulated on the negative through handling, rewinding and other usage.

After being "frosted" the negative when examined on the polished side really has the appearance of being frosted the same as a glass electric bulb. You can no longer look through its highlights as you can through the clear negative.

This effect it is claimed gives the prints a soft pastel effect that is not obtainable in any other way. It does not deter from the photographic quality of the prints, according to authorities on this process and those who have used it. It is further claimed it reduces the grain.

It is believed this grain reduction in the photographic reductions comes about because the light from the printing lamp instead of only front lighting the grain, is now dispersed in such way because of the minute abrasions that they become diffused about the grain and cross-light it as well as front light it, no longer throwing harsh shadows.

The European confidence in this method is so great that a great majority of them MATTE every negative before prints are taken from it. They find the negative will stand a greater amount of abuse; that rubbing it will not harm it after it has been "frosted," and they are desirous of obtaining the photographic quality in their pictures that only this process can give them.

The value of a process of this nature is unquestioned for negative use. With production costs reaching the heights they do reach and all of this investment finally reduced to a negative, it is evident that studios will find a method of this nature a boon especially when their valuable negatives are involved. It will no longer be necessary to discard any shot on a production because of negative scratch or abrasion. The first choice which has on many occasions been put aside because of a similar condition can now be used.

Technicians who are familiar with this process are definite in their opinion that it not only improves the printing quality of the negative by the removing of scratches and abrasions, but inherently results in less grainy prints.

Several of the major Hollywood studios have used this process on some of their negatives which were scratched and otherwise marred on the polished celluloid side. The method has not come into general use in Hollywood but is rapidly being recognized.

Perhaps this softened photographic effect from 'frosting' is another one of those things we have been terming "European technique."

The process was originally brought to America by Carroll Dunning of the Dunning Process Company who investigated its use in Europe on a recent trip across the Atlantic.

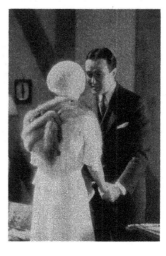

"Frosting" the 35mm negative not only took out the scratches, but gave a softer photography ... better highlights. Compare this with enlargement at top of page which is taken from same negative before being "frosted."

WHO CAN GAUGE
ITS TOTAL VALUE?

EASTMAN Super-sensitive Panchromatic Negative has helped the motion picture industry to attain improved working conditions...lower lighting costs...finer photography...better prints...higher screen quality.

Who can gauge the total value of this film's contribution? Without the qualities which it offered, the industry would have missed some of the most important stimuli it has ever received.

Further improved since its introduction, Eastman Super-sensitive is rendering its greatest service in the gray-backed form in which it is now available. Eastman Kodak Company (J. E. Brulatour, Inc., Distributors, New York, Chicago, Hollywood).

EASTMAN SUPER-SENSITIVE
PANCHROMATIC NEGATIVE (GRAY-BACKED)

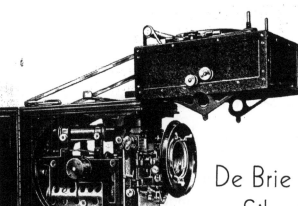

Upper photo shows the interior of the new de-Brie camera, while the lower photo gives you a comprehensive idea of the size of the camera itself if compared with the man.

De Brie Announces
Silent Camera

by

William Stull, A.S.C.

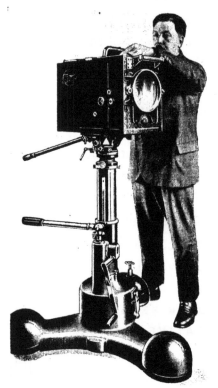

FROM time to time, cinematographers, directors and others returning from Europe have brought reports of an absolutely silent camera in general use in the European studios. According to the data which has reached us, the de Brie Super Parvo is absolutely sound-proof, and entirely eliminates the need of blimps, bunga-lows, or soundproof bags and blankets. It may be oper-ated uncovered less than three feet from the microphone. Since it does away with the need of the bulky, weighty blimps, it should permit decidedly faster, more efficient operation than is now possible.

The new Super Parvo is said to retain most of the salient features of previous de Brie cameras, with the addition of several fitting it to present-day conditions. The general appearance is much like that of the earlier models, though the case is naturally somewhat larger, due to the use of 1000 ft. inside magazines. The general arrangement of the components is the same as in the previous models.

M. de Brie takes particular pride in pointing out that he has not achieved silent operation by the elimination of any vital parts of the camera, but by silencing and sound-proofing his already well-known design. All of the features of the previous models have been retained:

1. Inside magazines (increased to 1000 ft. capac-ity.)
2. Standard lens-mounting, permitting the use of any lens, regardless of make, focus or opening.
3. Focusing directly on the film, and the ability to follow the action on the film during photograph-ing.
4. Focusing directly on ground glass of the exact size and position of the aperture, without mov-ing either camera or lens.
5. Special "Optis-de Brie" viewfinder.
6. Automatic, built-in shutter dissolve.
7. Pilot-pins and intermittent pressure-plate.

This latter feature is regarded as particularly valuable, as it minimizes the danger of aperture-scratches on the

Continued on Page 40

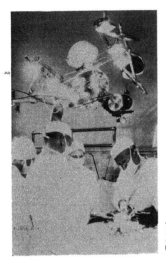

The 16 mm. is assisting science in the hospital.

Motion Pictures in the Universities

by

Earl Theisen

Honorary Curator, Motion
Pictures, Los Angeles Museum

THE leaders of education have become aware of the cinematic power of approach, of its forcefulness of introducing new things, of its manner of creating lasting impressions, and of its spur to the imagination.

Several universities have adopted it, however the supply of suitable pictures is inadequate to carry through a program using this medium. There is a definite need for pictures made in keeping with the academic mode of instruction. Many pictures along educational lines are being made by commercial concerns, and while well made are not cooperative with the school programs.

Still other pictures are being made by many having 16 mm. equipment, a great number of these being college graduates. These graduates are professional men who go on various expeditions, or are practicing surgery, medicine, dentistry, and other fields as varied as college specialization. An unbelievably large number of these men are making pictures of their procedures in their profession as a form of personal amusement as a hobby. As was shown in the recent contest staged by the American Society of Cinematographers these pictures are in keeping with the teaching and training offered them by their "Alma Mater" and are along lines

that would make them valuable as educational films in keeping with the academic life from which they graduated.

Logically, it should follow that these forces ought to be organized. But, just how go about such a mammoth undertaking? The alumni Associations could do more than any other group by setting aside a panel or committee for the express purpose of organizing and furnishing cooperative material in the way of scenarios and of bringing the film after made into the classroom. Such a move would be comparatively easy to crystallize, since there is a poignant need for the pictures, and they are already being made in an unorganized way by the alumni members. It is just a question of bringing the two together, and the group taking the initial steps certainly will build a monument.

On December 15th, 1932 the Chicago Cinema Club presented a program of scientific pictures to its membership, all of which, we understand, were made by amateurs. They included "Intracapsular Cataract Extraction by the 'Vacuum Cup' Method", by E. R. Crosley, M. D., Chicago; "Surgical Photography in Kodacolor," "Amateur Cinematography for Technical Teaching" by Arthur W. Proetz, M.D., St. Louis, Mo.; "Irrigation of the Maxillary Sinus through the Natural Ostium" by Walter H. Theobald, M.D., Chicago and "Mechanics of Acute Appendicitis" by C. Van Zwalenburg, M.D., Riverside, California.

This gives some evidence of what the professional university graduate is doing with his 16 mm. camera. It takes but little imagination to realize what a potent force he could be developed into in the furnishing of educational pictures for his alma mater if properly directed. With a scenario furnished him by his school, he would not only be taking the sort of picture which he delights in photographing, but he would be turning his camera to an educational force never before thought of by him or those in need of this material. It merely requires the organizing of the University Graduate 16 mm. user. The university wanting pictures of some particular angle of the science it is teaching, will undoubtedly find it in a shorter time by making its needs known to her graduates than in attempting to locate that particular subject through its own producing forces.

An engineer may be operating on the particular problem the school is endeavoring to teach its students. He may be working it out practically. His photographic record of this particular operation would be of inestimable value to his University.

Sponsored pictures made for publicity by the large corporations are not a solution to this need although they
Continued on Page 41

The eclipse permitted many scientists using 16 mm. cameras to apply their hobby to their work.

PHOTOGRAPHY
of the MONTH

"A FAREWELL TO ARMS"
photographed by **Charles Lang, A.S.C.**

Once in a long while comes a picture so perfectly photographed that it can stand as a milepost in the progress of the Art of Cinematography. "A Farewell to Arms" is such a picture. It is superbly, inspiredly photographed by Charles Lang, A.S.C., who, by this achievement, should gain universal recognition as one of the few really great masters of the camera. In almost any other production, such outstanding cinematography would distract attention from the story: but "A Farewell to Arms" is a great story, brought to the screen with great direction and great performances; it demands equally great cinematography. Anything less than Lang's superb camerawork would have been anticlimactic; as it is, the combination is very close to perfection in every department.

Primarily, "A Farewell to Arms" is a study in the Art of lighting. Lang has reached amazing heights of artistry in this, nor has he descended to the obvious in any scene. His lighting of the players is perfect in its absolute naturalness; it shows them off to the best advantage, yet conceals all trace of artifice. His lighting of the sets is superb. Every shot is a masterpiece of intelligent pictorialism. The lightings enhance the richly atmospheric sets, and are moreover supremely intriguing in themselves. They merit the careful study of every student of this subtle art.

Many of the outstanding sequences of the film are dialogueless, relying entirely upon photography and pictorial action for their expression: they are flawless passages in the poetry of the cinema. The combination of Frank Borzage's inspired direction and Lang's inspired photography have combined to make this production a memorable example of visual narration. The sequence depicting "Fedrico's" desertion is especially notable in this respect. Farciot Edouart's contributions in the way of process photography are also more than ordinarily notable. "A Farewell to Arms" is, in fact, that rare thing, a production in which every department of the studio, every individual artist and technician, has functioned perfectly, and in ideal coordination. Yet to the cinematographically inclined, it is above all an example of flawless cinematographic artistry, for which Charles Lang will always be remembered.

"THE ISLAND OF LOST SOULS"
photographed by **Karl Struss, A.S.C.**

Here is a film of the horror genre which is notable chiefly because of the extraordinary qualities which Karl Struss has invested its macabre photography. The settings are imaginative in the extreme, and allow Struss' artistry full play. He has contrived some notable effect-lightings. An important phase of the matter is the manner in which he has extended these effect-lightings to aid the characterizations in more than a few scenes the figures and faces of the actors are in more or less heavy shadows. In one shot of Charles Laughton, for example, at least half the scene is played with the man's face entirely obscured by the shadow of some venetian blinds: and although at the end of the scene he advances into the light, by far the most effective portion is that in which the player is but a vague figure, half-hidden by the shadow.

A great deal must also be said for Farciot Edouart's process photography, which is exceedingly good.

"SECOND-HAND WIFE"
photographed by **Charles G. Clarke, A.S.C.**

This production is one of the finest examples of the elusive art of high-key lighting that we have seen in a long time. When confronted with such a problem as this—including extremely light-colored sets—it is very easy to "miss fire", and very difficult to sustain mood and quality through an entire production: but Charles Clarke, A.S.C., has succeeded perfectly in this instance. Moreover, he has lit and photographed his players to more than ordinarily good effect. He has also maintained a rich, soft quality which is highly pleasing.

Hamilton McFadden, who both adapted the script and directed, deserves great credit for having done a most pictorially-minded job on both assignments. One sequence showing Sally Eilers mourning in her dead baby's nursery is one of the most finely conceived and executed sequences I have seen in many a day. It is played without a word, with the emotional burden carried entirely by action and photography, assisted by a fine musical background. Another notable sequence is one which utilizes the possibilities of the sound-film powerfully: it is played at a speed-boat race, and the emotional message of the scene is conveyed again in pictorial action, with the sound-effects serving to heighten the mental chaos in the star's mind.

The makers of this picture must also be complimented on their transitions, for they have avoided the use of "wipes", and held to lap-dissolves and cuts, which are vastly more effective.

"ROBBERS' ROOST"
photographed by **George Schneidermann, A.S.C.**

Photographically, this production is a better-than-ordinary example of the genus Western; but whatever merit there is in the film is entirely attributable to George Schneidermann, A.S.C. The opening sequence is highly effective, and lends itself well to the needs of the amateur producer. The exteriors are excellent, beautifully composed and filtered. But there the merit of the film ends abruptly, for the direction and continuity are unbelievably bad, not to say amateurish.

"MADAME BUTTERFLY"
photographed by **David Abel, A.S.C.**

This film evidences some of the most exquisite work that David Abel, A.S.C., has done in some time. He had tremendous opportunities in the Japanese setting of the story, and he has turned them to good advantage. The film is a gem of restrained, sombre pictorialism, interspersed with exquisite closeups of Sylvia Sidney in the title role. There is a highly effective sequence toward the end of the

sembling themselves along a production-line. The idea and its realization are both novel and effective.

The print in this case was far better than is often the case with the foreign pictures shown here. In addition to the poor laboratory work which we are informed mars Europe's production, the dupes sent to this country are execrable, and do not give the production or any of the individuals connected with it fair representation. In view of the rather limited distribution available to foreign-language films here, it would seem by far a better policy to send the best possible prints rather than inferior dupes. This is doubly necessary because of the poor projection often inevitable in the small theatres catering to the foreign film's audiences.

On another foreign film recently seen—likewise an UFA production—the American distributor had grossly mutilated the print, removing the original main and credit titles when he added an English-language synopsis. The production in question was, if I remember correctly, "Zwei Herzen und ein Schlag," a very excellently directed and photographed film treated in the Lubitsch-Mamoulian rhythmic manner, and photographed much in the American style. It is highly unjust that the names of both the director and the cinematographer should have been missing from both the screen and the exhibitor's press-book.

picture, in which "Butterfly's" fruitless night-long vigil, awaiting the return of "Pinkerton," is shown in a series of lap-dissolved shots of "Butterfly's" face, in closeup, and long-shots of her figure at the window, the fleet in the harbor, etc. The lighting of these briefly and surely tell the progress from expectant evening to disillusioned morning. The treatment of "Butterfly's" suicide is also telling.

"LIEBESWALZER"
photographed by **W. Brandes and K. Tschet**

Although this UFA production was made approximately two years ago, it is one of the most finished examples of film-production that Germany has sent us in some time. The lighting is decidedly on the American style, and very well done. There are a number of very clever touches in the-camerawork and direction, some of which—like the opening sequence—can well be emulated by the amateur. This sequence serves to establish the scene as a great American mass-production automobile factory; the means to this end is a swift sequence of stop-motion shots of cars as-

"THE DEVIL IS DRIVING"
photographed by **Henry Sharp, A.S.C.**

While this is an unpretentious little picture, it nevertheless shows Sharp's skill in lighting to good advantage. Henry Sharp has an unusual knack of photographing people effectively yet without a trace of artifice—and in this film he has also achieved the difficult feat of making attractive a picture in which a large part of the action takes place in a metropolitan garage. The garage sets are, in themselves, as far from pictorial as can be imagined: but Sharp's lighting adds a considerable measure of visual interest without in the least committing the error of idealizing the scenes.

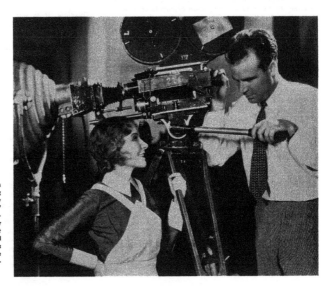

Whether Helen Hayes is congratulating Charles Lang for his exquisite photography in "A Farewell to Arms," or whether Lang is congratulating Miss Hayes for her superb acting we do not know, as they didn't send the sound track with this photo . . but both are deserving of mutual felicitations.

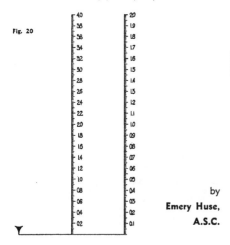

Fig. 20

Explaining
the "Gamma"

Part 20
of "Principles of Sensitometry and
their Practical Application."

by
Emery Huse,
A.S.C.

A GRAPHICAL representation of the H and D curve in Figure 19 Part 19 is sufficiently complete to allow for the computation of most of the sensitometric constants. Probably the most important single constant—at least from the standpoint of the motion picture laboratory—is gamma, which is commonly written in its Greek letter form "γ". It is hoped that in this article gamma will be clearly defined and that furthermore any misapprehensions as to its relations with contrast, with which it is so often confused, will likewise be cleared up. To properly define and make clear what gamma is it will be necessary to resort to a combination of simple arithmetic, plane geometry, and elementary trigonometry.

If reference is made to Figure 19 it will be observed that in the geometric construction of which that figure is composed a complete right triangle can be outlined. It is contained between the letters BNX. In this triangle there are the characteristic geometric elements such as the base, XN; the altitude, BN; and the hypotenuse, BX. It is definitely known by definition that the angle at N is 90° because it was stated that this was a right triangle. The values of the angles at X and B are unknown. However, for the purposes of this discussion they are not necessary.

In the right triangle, BNX, the lengths of the altitude, BN, and the base, XN, are known. For our photographic requirements, ie., the arriving at a definition for gamma, it is not necessary to know the actual angle value in degrees at X. What we do want to know is the slope of the line BX because it is the slope of this line, which incidentally is the straight line portion of the H and D curve, which gives the numerical value of gamma. In the mathematical subject of plane trigonometry the slope of a line, such as BX, can be determined from the very simple formula which states that the tangent of an acute angle of a right triangle is equal to the altitude divided by the base. In other words

$$\text{Tangent of an angle} = \frac{\text{altitude}}{\text{base}}$$

or

$$\text{Tan } X = \frac{a}{b}$$

With any H and D curve it is possible to construct a right triangle similar to that shown in Figure 19. In such instances the altitude expressed in density units is known and the base expressed in log E units is likewise known. Referring specifically to Figure 19 the altitude is expressed as the density difference between B and N. The density at B from this figure is 1.90. The density at N is 0.00. The difference between them, therefore, is 1.90. This, then, is the numerical length of the altitude. The base extends from log E values of 1.00 at X to 2.90 at N, giving a difference of 1.90 as the length of the base. Now, we have just stated that the

$$\text{Tan } X = \frac{a}{b}$$

Therefore, if as was previously stated, the tangent of this angle gives the slope of the line BX, which is the straight line portion of the H and D curve, then the numerical value of this tangent is the gamma of the straight line portion of that curve. In this instance, therefore,

$$\text{Tan } X = \frac{1.90}{1.90} = 1.00$$

Therefore, the gamma of the straight line shown in Figure 19 is 1.00.

If, for example, the altitude had measured 1.90 and the base, 0.95, then

$$\text{Tan } X = \frac{1.90}{0.95} = 2.00$$

Likewise, had the altitude measured 0.95 and the base 1.90, then

$$\text{Tan } X = \frac{0.95}{1.90} = .50$$

Fortunately it is not necessary in present day sensitometry to compute for gamma mathematically. Figure 20, accompanying this article, shows a print of a transparency which is referred to as a gammeter. If the little arrow indicated at the left end of the base line is placed anywhere along the lower portion of the straight line of the H and D curve and the base line of the gammeter is maintained parallel to the log E axis, then the point on the numerical

Continued on Page 43

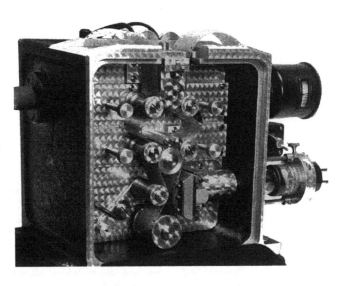

A T E U R S !

0 0

LLYWOOD
EXPERTS

TO HELP YOU

THE AMERICAN SOCIETY OF CINEMATOGRAPHERS
through its publication THE AMERICAN CINEMA-
TOGRAPHER has inaugurated a free service to the ama-
teur motion picture maker . . . a service that extends in
every line of picture making in which the amateur might
be interested. His questions will be answered by noted
authorities . . . by men working every day in the pro-
fessional field . . . men who have made hundreds of pic-
tures . . . men acknowledged the world's greatest
authorities in their respective branches of the industry.
More than 100 experts through this service will help
you on technical matter . . . assist you in the construc-
tion of your stories if you wish . . . give you suggestions
. . . and constructively criticize your pictures after you
have made them. No other magazine or Society could
give you the benefit of the experience of such great
authorities . . . men whose time is worth millions of
dollars a year . . . It's all yours for the asking. Write
your questions and problems to THE AMERICAN CINE-
MATOGRAPHER, 6331 Hollywood Blvd., Hollywood,
Calif.

AMATEUR SECTION

Contents · · ·

Next Month · · ·

● ENLARGEMENTS from 16 mm. film . . . the different methods that can be used to secure satisfactory prints, together with developing formula and reproduction of photos secured by some of the methods.

● A NEW STOP MOTION DEVICE . . . a corking article contributed by Alan C. Wooley and George V. Morris. Giving detailed description of the construction of this device and its use.

● WIPE-OFFS . . . how to make them by a member of the American Society of Cinematographers. A professional will tell you how wipe-offs are made . . . something that every amateur will want to incorporate in his bag of tricks.

● A HOME MADE 16 MM. CAMERA. Raymond Harvey will tell you how he built this camera . . . incorporating fade-in and fade-out device . . . an exposure meter and other gadgets built right into the camera itself.

● AND there will be other articles you will not want to miss.

And So

THE PRAISE POURS IN

IN NOVEMBER Victor announced the New MASTER MODEL 10 SERIES promising the movie world a 16 m/m Projector far in advance of the rest in BEAUTY, FEATURES, CONVENIENCES and PERFORMANCE — not to mention VALUE!

Movie Makers have come to know that when Victor announces improvements, *Something Really New, Something Decidedly Worthwhile,* is in the offing. In spite of that, the appearance of the Master 10 Series created a "stir" such as the industry has not known for many a day for even the most ardent Victor Boosters failed to anticipate a projector as fine as this!

And so the Praise Pours In —

From dealers, new purchasers, old Victor Boosters and prospective buyers comes a flood of enthusiastic endorsements of this latest Victor achievement! More and more dealers everywhere are switching to Victor exclusively. More and more buyers everywhere are learning that these new Victors are unmatched in everything the careful buyer wants — BEAUTY, PERFORMANCE, COMPLETENESS, VALUE! If you haven't seen the new VICTOR 10's, give yourself a treat Ask any Dealer. For illustrated descriptive literature and name of nearest dealer, write direct.

MORE POWERFUL 400 W - 100 V
Illumination

VICTOR ANIMATOGRAPH CORPN.
DAVENPORT, IOWA

EASTERN BRANCH, 242 W. 55th, NEW YORK CITY
WEST COAST BRANCH, 650 So. Grand, LOS ANGELES, CAL.

Sold by Better Dealers Everywhere

MODEL 10 VICTOR MASTER
16 mm Series *Projectors*

EQUIPMENT WINNERS....
AMATEUR MOTION PICTURE CONTEST

BY VIRTUE of the conditions laid down by the manufacturers and distributors who contributed equipment prizes most of the prizes offered were given to those winning the major prizes awarded last month. The only exceptions were the prizes offered by the Eastman Kodak Company, Victor Animatograph Company and William J. German (J. E. Brulatour Inc.)

EASTMAN KODAK COMPANY prize for the finest example of photography in any out-of-door picture whether it wins a cash prize or not was awarded to Tatsuichi Okamoto, Maysuyama, Japan, for "Early Summer," 1 reel. This is a different subject than the one which won him the second prize.

VICTOR ANIMATOGRAPH COMPANY prize of a Victor Model Five camera, complete with 2.9″ Hugo Meyer Lens and No. 5 carrying case for the film which, in the opinion of the judges would most nearly qualify for a major prize, excepting for insufficient photographic quality, was awarded to Lieut. D. W. Norwood, Randolph, Texas, for his picture "Skylark."

The $20.00 certificate of credit for the best picture from each state that was not included, among prize winners offered by Victor Animatograph Company went to:

ALASKA—V. A. Morgan, Warton, for "Hunting Dalli Sheep."

CALIFORNIA—A. R. Powell, Azusa, for "Kathryn and Her Silkworms."

COLORADO—Dr. Wm. Haggart, Denver, for "Coyote Hunt."

CONNECTICUT—Bruce Lindsay, Windsor, for "Mortgaged."

FLORIDA—H. W. Voss, Ft. Meyers, for "Wonderful Wyoming."

ILLINOIS—Glenn Steele Bowstead, Chicago, for "Roped."

IOWA—Elton Legg, Council Bluffs, for "Zeppelin of the Rails."

LOUISIANA—Dr. S. H. McAfee, New Orleans, for "Maxillary Denture."

MASSACHUSETTS—Henwar Rodakiewicz, Buzzards Bay, for "Portrait of Young Man."

MARYLAND—A. Leslie Gardner, Hagarstown, for "Haddonfield in 1890."

MAINE—H. M. Armstrong, Cape Cottage, for "Maine Coast."

MICHIGAN—Walter Gaertner, Grosse Pt. Park, for "Twilight Slumber."

NEW YORK—Charles Kaufman, Woodside, L. I., for "Metropole."

NEW JERSEY—Theo. C. Huff, Englewood, for "Little Geezer."

OHIO—Clyde Hammond, Youngstown, for "Girl and a Dress."

OREGON—Edw. J. Schon, Portland, for "Art of Photoengraving."

PENNSYLVANIA—Margaret L. Bodine, Philadelphia, for "Humming-birds."

SOUTH DAKOTA—Ralph Newcomb, Vermillion, for "Out Along the U. P."

TEXAS—Prof. W. M. Winton, Fort Worth, for "The Indian Country."

WISCONSIN—Milwaukee Movie Makers, Milwaukee, for "Yo-Ho!"

WEST VIRGINIA—Greenbrier Amateur Movie Club, White Sulphur Springs, for "Two Minutes to Play."

WILLIAM J. GERMAN cash prize of $25.00 for the picture having the best composition went to Tatsuichi Okamoto, Maysuyama, Japan, for "Lullaby," the picture which gave him the second major prize offered by THE AMERICAN CINEMATOGRAPHER. $25.00 for the picture considered the most ideal home movie went to T. B. Hoffman, Los Angeles, Calif., for his picture "Finney Fable."

BELL & HOWELL COMPANY prize of a choice of a Filmo 70DA camera or a Filmo J. L. projector to the winner who made his picture with a Filmo camera went to Wm. A. Palmer and Ernest Page for their picture "Tarzan Jr." The second prize offered by Bell & Howell; choice of Standard Cooke Telephoto Lens was awarded to S. W. Childs, winner of the Third Major Prize for his picture "I'd Be Delighted To!" which was made with a Filmo.

MAX FACTOR MAKE-UP STUDIOS prize of one of the famous Max Factor Make-up Kits to the winner of first prize automatically went to Messrs. Palmer and Page for "Tarzan Jr."

HOLLYWOOD FILM ENTERPRISES offer for the best film from California whether it won a major prize or not was given to Palmer & Page for "Tarzan Jr.", they being located in Palo Alto, California. This prize consisted of a Model B Cine Voice Home Movie Talking Machine, complete with carrying case.

HOME MOVIE SCENARIOS INC. awarded Palmer & Page one scenario, choice of one HMS matte box, choice of any HMS filter and one HMS scene slate.

To winner of second prize which went to Okamoto in Japan, one HMS matte box and choice of any HMS filter.

METEOR PHOTOLIGHT COMPANY presented winners of fourth prize, Greenbrier Amateur Movie Club, White Sulphur Springs, W. Va., a Meteor Double Photolight, complete with 500 watt Neron bulbs. A Meteor Photolight Tripod, complete with Neron bulbs. Meteor Photolight, table model, complete with bulb.

WINNERS OF
CERTIFICATE AWARDS

AWARDS for Distinctive Achievement in the different phases of motion picture making were granted those contestants who showed high individual merit in the different types of motion picture making.

Those receiving Certificate of Awards are as follows:

First Awards:

PHOTOGRAPHY°—E. W. Walker, Beverly Hills, Calif., for "Yosemite"; Henwar Rodaklewicz, Buzzards Bay, Mass., "Portrait of Young Man."

KODACOLOR—H. W. Voss, Ft. Meyers, Fla., for "Wonderful Wyoming."

HOME MOVIE—T. B. Hoffman, Los Angeles, Calif., for "A Finny Fable."

PRODUCTION—Theo. C. Huff, Englewood, N. J., for "Little Geezer."

SCENIC—E. W. Walker, Beverly Hills, Calif., for "Yosemite."

ANIMATED CARTOON—Wagoro Aral, Tokio, Japan, "Walking of Baby Boy."

NEWS REEL—Charles Meulemans, Hollywood, Calif., for "Xth Olympiade."

NATURE STUDY—A. R. Powell, Azusa, Calif., for "Kathryn and Her Silkworms."

MEDICAL—Dr. S. H. McAfee, New Orleans, La., "Preparation for Maxillary Denture."

TECHNICAL PROCESS—Edw. J. Schon, Portland, Ore., "Art of Photoengraving."

EDUCATIONAL—Lt. R. C. Wriston, Rantoul, Ill., for "Trail of the Eagle."

TRAVEL FILM—Dr. Z. Bercovitz, Chosen, Korea, for "Glimpses of Life in the Hermit Kingdom."

AERIAL PHOTOGRAPHY—Wayne H. Fisher, Los Angeles, Calif., for "Winter Air Trails of the Sierra Madre Mountains."

Second Awards:

KODACOLOR—H. M. Armstrong, Cape Cottage, Me., for "Lore of the River."

HOME MOVIE—Glenn S. Bowstead, Chicago, Ill., for "Roped."

PRODUCTION—Bruce Lindsay, Windsor, Conn., for "Mortgaged."

SCENIC—Delmir de Caralt, Barcelona, Catalunya, Spain, for "Montserrat."

NEWS REEL—Charles Rhein, Oude God, Belgium, for "Anvers Exposition."

NATURE STUDY—Margaret L. Bodine, Philadelphia, Pa., for "Ruby-Throated Humming-Bird."

EDUCATIONAL—R. P. Ewing, New York City, for "Red Hell of the Kaniksu."

TRAVEL FILM—Comte de Janze, Paris, France, for "Safari."

°Because each of the winners of awards for photography were given the same number of points, two certificates were issued for that achievement. It will also be noted that Mr. Walker was also given a certificate for "Scenic" for the same subject. His photography, filter work and composition gave him a high standing in both classes.

HONORABLE MENTION—

Walter Gaertner, Groose Pt. Park, Mich., for "Twilight Slumber."

Kichi Takeuchi, Koyto, Japan, for "Sister and Brother."

Clude Hammond, Youngstown, Ohio, for "Girl and a Dress."

D. Kengt, Eindhoven, Holland, for "Twenty-five Guilders."

Victor Bracher, Pilot Rock, Ore., "Babbling of Old Man River."

Harry C. Aberle, Jenkinstown, Pa., for "Relaxation."

Wm. H. Barlow, Jersey City, N. J., for "Poetry of Nature."

R. B. Ashbrook, San Gabriel, Calif., for "Over the Garden Wall."

R. R. Hartmann, Sierra Madre, Calif., for "Romance of a Feminine Monarchy."

Jack Navin, Crosse Pt. Park, Mich., for three dramatic productions.

Franklin W. Marling, Chicago, Ill., for "A Merry Xmas, 1931."

Alfonso Squeo, Bayonne, N. J., for "Sacrifice."

Milwaukee Movie Makers, for "Yo-Ho."

Prof. W. M. Winton, Ft. Worth, Texas, for "The Indian Country."

V. A. Morgan, Warton, Alaska, for "Hunting Dalli Sheep."

Louis Loose, Anvers, Belgium, for "1932—A Day."

Stefano Bricarelli, Turin, Italy, for "Luci di Parigi."

W. J. Seeman-C. E. Memory, Hollywood, Calif., for "After Dark."

Charles Kaufman, Woodside, L. I., for "Metropole."

C. F. G. Chapman, Los Angeles, Calif., for "Yellowstone National Park."

1933 AMATEUR COMPETITION

THE 1933 Competition for Amateur Motion Picture Makers will be conducted along slightly different lines than our 1932 contest. While the basis of the competition just completed was the awarding of a first, second, third and fourth prize, it was found after viewing the hundreds of reels submitted that it was impossible to do the amateur justice in such few classifications.

Instead of a one, two, three, four order, this year's competition will include the various phases of picture craft as demonstrated by the subjects submitted in 1932. On the preceding page you will find the different classifications represented in last year's pictures. It is along this line that the 1933 competition will be handled.

Entrants are asked to mention the classification under which they enter their film so that it can be judged in that group.

There will be no money prizes. The recognition will consist of a medallion which can be attached to the winner's camera as an indication of the award he received.

We have talked to hundreds of amateurs on this phase of recognition and they feel it is the greatest honor any amateur can achieve the recognition of the American Society of Cinematographers.

The competition will be open to all bona-fida amateurs, whether they are subscribers of The American Cinematographer or not. It is only asked that the Entrant have had no professional assistance in the making of the picture. It will be confined to 16 mm., 9½ mm. and 8 mm. film.

Entries must be in the office of The American Cinematographer not later than October 31, 1933.

We will announce further details in later issues.

MEET THE PRIZE WINNERS
ERNEST W. PAGE AND WILLIAM A. PALMER

EDITOR'S Note: We feel there is so much of the personality of William A. Palmer injected in his reply to our query for information of his vocation, his age and how he happened to be a 16 mm. user, information we sought for a biographical sketch of him and Ernest Page, that not to give it to you just as Palmer wrote it to us in his youthful, straightforward way without any inhibitions, would be taking much away from your appreciation of the achievement of these two youngsters.

I MET Ernie Page four years ago when, as an enthusiastic owner of a movie camera, he had organized an amateur club at Stanford University. The club had started on its maiden project, a photoplay of college life, when our acquaintance started. I was a senior in high school and had been an enthusiastic movie bug for some three years before, making various short films on a home made 35 mm. camera, the 16 mm. cameras of the day being too far from the capacities of my purse. The upkeep of the larger size outfit was reduced by the use of positive film for both negative and print. Quality? Oh boy!

Ernie very readily accepted my offer to use the 'laboratory" in my basement as the headquarters for the "Stanford Studios," his amateur club, and the work progressed on the big production. Ernie was the director and another chap and I did the photography on the picture that finally became the four reel comedy, "The Fast Male."

Subsequently the "Stanford Studios" disintegrated as many such organizations do, but Ernie and I continued our cinematic activities together. The acquaintance made through mutual interest in a hobby has grown into a fast friendship.

In the following years as Ernie finished Stanford and continued in its medical school and I started my college career, we had a chance to produce a few films in the summer vacations. The school year was too filled to do anything more than make incidental record pictures. I had given up the old 35 mm outfit and managed the purchase of some 16 mm. equipment, which together with that that Ernie owned made quite a complete set up. We pooled all the equipment and have since worked under a sort of joint ownership of everything, although each particular unit is the property of one or the other. In some cases there is uncertainty as to whom some article of cinema apparatus belongs.

In the summer vacations preceding the last we made two photoplays. The first, "Wages of Cinema," a two reeler starring a group of high school kids, had a theme very similar to "Tarzan Jr." in that there was a movie within a movie. The shortcomings of this picture prompted us to try the theme again with more effort on the continuity. The other picture preceding 'Tarzan" was "Boscoe the Bad Man," a two reel melodrama made at the Lokoya Boys Camp. This was a semi-burlesque of the adventure drama and had the boys in the camp as actors. It was a wild story of horse thieves and man hunts and while not extremely successful, because of some rather elaborate scenes with a large cast, it was a lot of fun.

This last summer again back at the camp with more opportunities for a photoplay, the present opus was born. I would like to look forward to another summer at the camp working with the boys and the movie camera, but it is not to be. I am afraid, this year we shall both be finished with school and will have to be thinking about getting to work and most lines of business do not permit of six week vacations.

While we have probably made every mistake possible at some time or other, we have been fortunate enough to have made most of them in the pictures before "Tarzan Jr."

At the present time Ernie and I are both Stanford students. He is extremely busy at the time with final examinations, so in the meantime I am the spokesman for the two of us. I am struggling to finish a course in engineering. I am twenty-one years old and Ernie is twenty-three.

Making A Prize Picture

by

**Ernest W. Page and
William A. Palmer**

Ernest W. Page and William A. Palmer, winners
of first prize in Amateur Motion Picture contest.

THE word "movie" is a magical one in imaginative young minds. It conjures up pirates, bloody battles, ferocious animals, and the proverbial crooks of the melodrama. To suggest the making of a photoplay to a group of eager youngsters is to assemble a cast in less time than it takes to tell about it. Their energy and enthusiasm are surpassed only by their inventive capacities.

A six week's vacation as counselors at the Lokoya Boys camp this last summer offered a rare opportunity to make a motion picture in which all of these youngsters could participate. Here were mountains and lakes, redwoods, and woodland paths, with seventy boys "turned loose" upon their surroundings. To direct their energies along constructive lines was one of the aims of the venture.

We called upon our young assistants to suggest a story. "Let's blow up a mountain in one scene!" offered a little tad whose inspirations exceeded his logic. "How about making a Tarzan picture and letting me climb trees?" said another.

There was the hint. Why not make a Tarzan picture? Why not let the boys themselves make the picture while we stood by with another camera and recorded their attempts? We could remember the troubles we ourselves had encountered in the past, and how amusing they seemed to us now. If we could burlesque these tribulations, show them trying to make a melodrama of Tarzan in the jungles, and finally show the result of their efforts as a movie within a movie, then we would have the basis for a good comedy.

We had a perfect setting for the Tarzan theme. Animals? Yes, there were horses that could be turned into zebras; an inverted canoe would furnish a good start on a hippopotamus; while a monkey suit with an assortment of animal masks would serve to represent a lion or a gorilla at will.

Something more was needed, however, than the simple burlesque on an amateur photoplay. We needed some human interest, something to show more properly the varied emotions of a boy. There was plenty of story material at hand. Each day, in the daily routine of camp life, we discovered that a youngster's ambitions were his greatest motivation, and the frustration of those ambitions the origin of many heartaches. With this in mind, we based our essential theme upon the desire of a small boy to become the director of the proposed opus, "Tarzan the Ape Man." The fact that he never realized his dream furnished bits of pathos to intersperse with the comedy.

In the direction of the picture, an attempt was made to maintain sincerity and restraint on the part of the actors, for without these two qualities, the amateur photoplay truly becomes amateurish. The fact that the characters of the story were "being themselves" helped immeasurably to obtain a natural performance. A boy does not have to be a great actor to play the part of a boy. It is only necessary that all vestige of camera consciousness be removed and the character put completely at ease. Natural acting will follow if the player has a normal amount of poise.

The photography was not at all pretentious. The story would not permit modernistic lighting effects or weird, distorted scenes; nor were filters, flares, fast lenses, and fancy focusing devices necessary for the simple plot. The endeavor was always to get a good straight shot with the proper placement of lights for interior scenes, and the consistent use of reflectors for exteriors. Composition was altered by the variation of camera angles only to the extent necessary to place the center of interest of a particular scene in the proper balance with relation to the other components. Extreme camera angles were used only when the dramatic values of the scene would permit them.

Only one actor was difficult to handle, our canine star, Patsy. She was a gentle police dog, and not at all inclined to leap at the throats of the arch-villains. During the midst of her great battle she would consistently prefer to lie down in the shade of a small shrub. Finally, by having the villain throw the dog from his shoulder to the ground and by holding the camera upside down, we obtained the desired effect, and Patsy jumped at the man's throat in quite a natural manner.

On another occasion, it was necessary for Patsy to run over to a small box on the ground, pick it up, and run down the trail. She would do everything but pick up that box. After several trials, we concealed some bacon within the box and threw it on the ground. The lid came off, the bacon rolled out, and our actress calmly sat on her haunches and munched bacon to the tune of twenty feet of film. Giving up in despair, we picked up our equipment and started back, only to find the dog following us with the

Continued on Page 43

Illustration No. 1—Home-made viewing, editing and splicing board with the author at work.

Illustration No. 2—Titling and filming table that has many uses.

I Make Them Myself

by

S. H. McAfee, D.D.S.

BEING something of a mechanical 'nut' I have gotten a great kick out of developing a 'near' automatic editing and splicing board that does most everything except talk. All from nothing up, one piece of wood and a few screws at a time.

Illustration No. 1 shows this home-made viewing, editing and splicing board being used by the author. It is an assembly of wood, screws, fragments of sundries, junk, and several manufacturer's parts, specially adapted and mounted. Home-made spring film-end holding fingers, film-end rais-

ers, clamps, cutting and scraping slide guides, etc. Both winders with cranks, elevated to accommodate any size reel up to 1200 feet.

But that's only one of the home made gadgets I have around my workshop . . . sometimes I find it in the kitchen or even in the living room. How my family puts up with me at times is a question for Job to decide.

If the editor of THE AMERICAN CINEMATOGRAPHER has tolerated the several pictures I sent to him, you'll find that:

Illustration No. 2 is a home-made titling and filming table. Camera and alignment gauge mounted on movable and adjustable wooden support. Back-ground board is adjustable to any position—forward, backward, side-ways, vertical or inclined. Camera-distance range from 1½ to 4 feet. Centering and framing is done altogether with view finder and alignment gauge; focusing with critical focuser. Two 500 W. portable Kodalites, a 22x24 inch piece of glass, held by adjustable support, in behind, has a piece of black show card board clothes-pinned to it. Glass preserves flatness otherwise heat from lights cause card to warp.

A hole, 10x12 inches is cut out of center of table. Over this is laid a piece of ground glass with suitably ruled lines as lettering guides and 'field' outlines of different sizes. Illuminated from under the table, shows lines through white (not black) paper. Useful for lettering, tracing, etc., though not essential. Glass removed, the same hole accommodates the vertical camera mount, lights, etc., shown in illustration number 3.

Illustration No. 3 is a vertical camera mount; carries alignment gauge in either normal or up-side-down (inverted camera) position.

Used for scramble-in, scramble-out soup letter titles, film-as-writing, 'un'-writing, 'sand-storms', etc. Camera distance 18 inches. (1 inch focusing mount lenses will focus at this distance although shortest calibration is 2 feet). This gives usably safe 'field' about 3x5 inches. Two B&H titling board lights give ample light. Underneath the board is a small electric 'buzzer' connected to 2 dry cells through push-button. The whole apparatus—camera, lights, board, buzzer, etc. all rigid in same relation—may be tilted or leaned in any direction. Actuating the buzzer, which touches underneath the card board on which the letters, snow-storm or what have you, is arranged and leaning the apparatus causes letters, etc. to 'jiggle', run, roll or slide OUT and OFF—or ON and IN if filmed upside-down and the film spliced in backwards, this reversing the motion on the screen and bringing the scene right-side-up. This, of course, is not new or original—the technic and apparatus may be.

A trigger-lever with a string hanging down conveniently operates camera push-button; makes "stop" camera filming easy—such as making one or two frames of one letter, one word or line at a time, animated graphs, drawings, etc.

Illustration No. 4. A magnifying film in an arrangement made of a modified Eastman titling board adapted to Filmo Camera mounted on alignment gauge. The magnifying glass, in front of one inch lens, set at infinity, focuses at about seven inches. This makes a small 1¼x2½ inch 'field' fill the frame—and the screen. Illustration shows single dental X-ray negative trans-illuminated by a photo flood light behind the large black card board. This makes

the small dental X-ray nearly fill the screen—and of course greatly magnifies it.

Illustration No. 5 is a home-made wooden film drying reel. Holds 100 feet 16 mm. film. Small fan blows and dries film and revolves reel like wind-mill. Illustration shows film being wound on reel off Steineman developing coil.

Titles for a scientific picture had best be in plain, clear white (on the screen) letters, without any ornamentation.. Some titles are necessarily long to be sufficiently descriptive, therefore too laborious to do by hand. Titles are, of course, spliced in later, while editing the picture.

For making intense black and white titles, drawings, trick experiments, etc., I use cheap positive film and develop it myself—with the same developer and fixer I use for dental X-ray films. If the title, or experiment, is not over 3 or 4 feet of film I do not even put the take-up reel in the camera. A few feet will coil around in the reel space and is easily clipped off with scissors in the dark room, leaving the camera threaded. The piece of film is then just 'doused' for about two minutes in a good size pan holding about ½ gallon of X-ray developer; washed for a minute in a pan of water, fixed for 2 or 3 minutes, washed again and hung up to dry. I used to think they would be scratched if you just looked at them while wet, but not so. No attention is paid to temperature of solutions. In longer pieces of film I use a Steineman reel-coil and flat pans developing outfit and can easily develop 100 foot roll, wash and wind in one piece on a small home-made paddle-wheel drying arrangement. A small electric fan both rotates the drying rack and dries the film in about 30 minutes. However, I do not develop my films of real pictures. I have the laboratories do that both for reasons of expedition and better results. But for plain black and white, or white and black, the cheap film, developed as stated, using the negative for projection gives excellent results. Of course if you want to screen the black and white AS DRAWN or WRITTEN a positive print must be made. I find it more convenient to write black letters on white paper for home-made titles. Developed as above, projecting the negative, gives intensely white letters on a dead black ground on the screen. This very elementary statement is made for the benefit of some rank amateur (like me) who might have to 'dig this information out' by experiment as I did, through of course real photographers all know it. My contact with a few amateurs has impressed me with how little of the rudimentary fundamentals we know to begin with and how circuitous a route is necessary to find out a few things. Camera and projector makers ought to give away a comprehensive textbook with each outfit. I have burned up (seemingly) miles of good film uselessly. This is of course music to the filmmakers' ears.

Personally my interest in amateur 16 mm. photography inclines toward camera and titling board 'trick' stuff and scientific pictures. The latter however, are of no interest to lay audiences to whom I do not show them.

I have a home-made table titling and filming arrangement with which I can film from 9 inches up to 4 feet camera distance. At nine inches through a magnifier, one inch lens set at infinity, an object or card 1¾x2½ inches fills the frame (and screen). At four feet the field is about 12x14 inches. Titles, back-ground, and letters of great variety of size can be framed and filmed. I also made a VERTICAL camera mount on the table, that adjusts to distances from 9 inches to 2½ feet. It provides for placement of the alignment gauge to hold the camera either normally or upside-down for convenient un-writing titles, cartoons, etc., and for scrambling in or out, letters, sand, steel balls,

Illustration No 3.—A vertical camera mount carries alignment gauge for normal or up-side-down position.

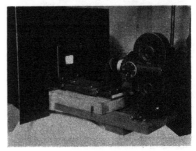

Illustration No. 4—A magnifying filming arrangement made of a modified Eastman titling board.

Illustration No. 5—A home-made film drying reel. Holds 100 ft. of 16 mm. film.

soup letters, etc., by electric vibration. A button-pusher arrangement operated by a string and lever, makes quick 'stop camera' animated drawings, cartoons (?) etc., easy.

Scrambled in, or out, alphabet soup letter titles make a great hit with children. I usually include one or more in the educational films projected to patients in my office, where I make almost daily use of a 16 mm. projector which 'screens' on a reception room panel from a concealed booth. I also make titles specially for any evening's 'show.'

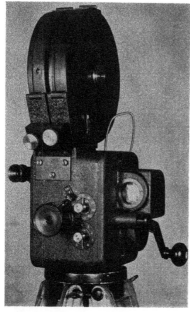

Rear View "Arri" camera, showing focusing magnifier at center and tachometer at right above crank

Enter—
Professional
16 mm. Camera

by

William Stull, A.S.C.

IT was Mark Twain, I believe, who remarked that although everybody talks a lot about the weather, nobody ever seems to do anything about it. The 16 mm. professional and his cousin the truly advanced amateur, it appears, about equally popular. Certainly we have from time to time heard a deal about them and their requirements; but we have heard very little about filling those requirements. There is a vast variety of equipment available for the novice and for the moderately advanced amateur: but until recently no one seems to have made any serious attempt at supplying the man who wants a 16 mm. equipment comparable to a 35 mm. studio camera.

This is in a way surprising, for there exists an increasing market for such equipment both with the professionals who make 16 mm. films for industrial and educational purposes and with those amateurs who want and can use equipment that will do more than the conventional amateur camera is capable of. Moreover, the earliest 16 mm. cameras—especially the redoubtable "Model A" Cine Kodak—were excellently suited to serve as a starting-point for such designs, while other still earlier substandard designs, like the 17½ mm. Wilart "Actograph" camera of 1918, were definitely attempts at making a professionalesque substandard outfit.

During the past year, however, several truly professional 16 mm. cameras have been announced here and abroad, with several more reported as all but ready for announcement. All of them feature such professional conveniences as 400 ft. outside magazines; forward and reverse cranking and takeup; 8:1 and 1:1 movements; direct focusing of the full frame on the film; and accurate footage and frame-counters. Some designs are also fitted with a tachometer, while others are designed for sound-on-film recording and bipack color cinematography. In addition, more than a few custom-made professional outfits have been evolved from the familiar "Model A" Cine Kodak, from Filmos, and the like.

Perhaps the most interesting of these professional six-teens is the one designed by Eric M. Berndt. In appearance, it resembles a cross between a Bell & Howell Studio Camera and an RCA-Photophone recording-head. It is fitted with 400 ft. external magazines of professional type, equalling, of course, the capacity of the 1000 ft. magazines used in the studios. The camera is hand-cranked, but can be driven by either a wild or a synchronous motor if desired.

The details are perhaps best described by Mr. Berndt, who states: "This camera is really designed for the purpose of incorporating sound-on-film. The main drive shaft runs on ball bearings. The movement is a high grade cam move-

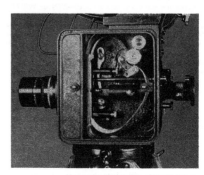

Movement and threading of "Arri" camera; note focusing tube running through center of camera

ment, made of tool steel, hardened and ground. It is somewhat on the order of a 35 mm. Mitchell, and is silent in operation. The film gate resembles that of a Filmo, is made of stainless steel and has side tension only; there is no direct pressure on the emulsion. The shutter-opening is 170 degrees, but may be had in any desired aperture.

"A focus-on-film microscope (Bausch & Lomb optics) with 10 x magnification, and showing an erect image, is supplied. The footage-counter is a standard Veeder-Root reset counter, and indicates up to 999 feet. The camera

has three outlets for the crank, two being on the side of the camera and one in the back. Those at the side are the tsandard (eight-picture-per-turn) and trick (one-picture-per-turn) movements. The outlet at the rear is also stop-motion, and may be used by hand, motor or flexible-shaft for synchronizing. The 400 ft. magazine is one unit, and may be removed from the camera by loosening a single screw. 400 feet of raw stock may be used as well as the usual 100 ft. daylight-loading reels.

"Camera and magazines are made of cast aluminum, finished in black crackle; other metal parts are chromium plated. Fibre gears are used in the mechanism. Reverse take-up may be accomplished by cranking the camera backwards and changing takeup belt from one pulley to the other. It is possible to incorporate a dissolving-shutter; I am working on this design now. A Goerz variable viewfinder is part of the regular equipment of the camera. There are standard mounts for four lenses on the turret, and any standard 16 mm. lens may be used. Being made as it is, the camera may be equipped with any of the devices or auxiliary parts with which a professional camera may be fitted. In other words I might say that my camera only differs from a professional 35 mm. camera in its size and weight."

Germany, too, has brought forth a camera for the 16 mm. professional. It is made by Arnold and Richter, of Munich, the makers of the well-known "Arri" printers, and is as distinctively European a design as the Berndt camera is distinctively American. It comprises an unusually compact camera-head, with two 400 ft. external magazines, placed side-by-side. Following conventional European practice, the camera is not fitted with a turret, though standard lens-mounts are used. The camera is hand-cranked, with 8:1 and 1:1 movements. It may, of course, be run either forward or backward. In addition to the regular frame and footage counters, the "Arri" camera is equipped with a tachometer, which indicates the speed at which the apparatus is being cranked. This—aside from its obvious value to the inexperienced crank-turner—is of great value in trick work and in securing special effects through the use of speeds above or below normal.

Focusing is direct on the film, through a magnifying system which gives an erect, magnified image. The finder is of the Newton type with a magnifying element.

Another German camera that falls somewhat within the province of this discussion is the Cine-Nizo 16 c. Actually, it is the link between the conventional hand-camera and

Movement and threading of the Berndt professional 16mm camera

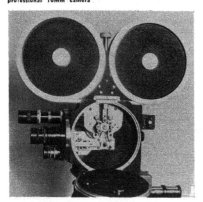

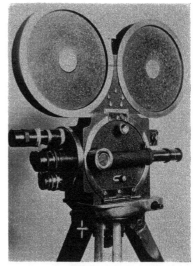

The Berndt professional 16mm camera. Focusing magnifier on door, finder not shown

the true professional 16. It is in fact a hand-camera, fitted with 8:1 and 1:1 hand cranks in addition to the spring-motor drive, and with a prismatic arrangement for focusing on the film. Its capacity is limited to 100 ft. of film, however, and it does not have the detailed refinements of the true professional camera.

These developments, together with the steadily increasing number of specially rebuilt Filmos, Victors and Cine-Kodaks that one sees in the hands of the advanced amateur, point definitely to considerable developments in this field within the next year. Even as the non-theatrical motion picture field is rapidly stabilizing itself with 16 mm. the standard for professional and advanced amateur use, and 8 mm. for real home-movie and cine-snapshooting, the equipment problem is bound to take a similar course, with 8 mm. and the super-simplified 16 mm. apparatus already extant devoted to the home-movie maker and the cine-snapshooter; today's deLuxe Filmos, Victors, etc., the tools of the larger class of moderately advanced amateurs; and such truly professional 16 mm. cameras as have been here described more or less custom-built for the professional, the scientist, and the extremely advanced amateur. And as the possibilities of 16 mm. become more and more fully realized, it is inevitable that the demand for these professional 16 mm. outfits should increase—though it is by no means small even today. Disregarding the large number of letters which annually reach this office, inquiring for just such equipment, I have been informed by the sales directors of several nationally-known firms that there is today demand for several hundred such outfits annually. In the future, and particularly until the presumably far-distant time when a truly automatic 16 mm. recording outfit is marketed, the demand for these professional 16s must inevitably grow, for only they offer any possibility of direct 16 mm. sound-on-film recording; and only they can offer the 16 mm. professional and the highly advanced amateur the possibility of studio-camera flexibility and 16 mm. economy. The day of the professionalesque 16 mm. camera is unquestionably here.

Schools

**Miss Marian Evans,
author of this article**

Editor's Note: This contribution by Miss Evans demonstrates the trend of schools to employ pictures in their education of the young with a strong trend toward the use of motion pictures for the older students. The leaning of the schools will undoubtedly be toward 16 mm. because of their flexibility, the ease of handling equipment, their lesser cost, etc. The San Diego public schools have more than 40 16 mm. projectors for use in this work.

THE photographic record is a teaching tool directly fashioned to meet the needs of modern education, which aims to teach boys and girls how to study as well as what to study, and not only to memorize facts but how to weigh and handle facts.

A recent analysis of over one hundred experimental studies and tests reveals that the proper use of illustrative materials increases initial learning, effects economy of time, aids in teaching backward children, decreases truancy, increases the permanency of learning and motivates lessons through interest, attention, self activity, voluntary reading and classroom participation.

In order to bring about these desirable results, like books and all other school equipment, visual aids must be selected with care to fit the needs and interests of the students and must be effectively used by the teacher. To insure economy and efficiency of our program, visual instruction centers, paralleling, but not duplicating the work of the school

libraries have been established as an integral part of the school systems. San Diego's department is a typical center ideally located in the heart of the civic cultural center in Balboa Park and its program radiates to the Natural History Museum, San Diego Museum, Scientific Library, Fine Arts Gallery and Zoological Gardens, for all of these institutions give objective and pictorial materials for the schools.

Briefly, the Visual Instruction Center serves as:

1. A collecting, selecting, organizing and distributing center of visual and other instruction aids.

2. A teacher training and advisory bureau in the technique and use of these materials.

3. A production plant and photographic laboratory for making curriculum instruction materials, especially of local, up to date and current subjects.

4. A testing division for evaluating present and future developments of visual materials and equipment.

5. A correlating and integrating center for educational organizations of the community such as museums, art galleries, zoos, etc., which may offer valuable services to the educational program.

6. A display Center for the exhibition of objective work of students, resulting from the activity program.

Our field includes 26,000 enrolled students covering grades from the Kindergarten to the high school and adult evening classes. It is necessary to maintain a staff which is carefully selected on a basis of training and experience. A representative staff for a well-rounded program might be listed to include the following members for a city with a population of from 150,000 to 200,000:

1. Director—In charge of the selection and purchase of all visual aid instruction materials and evaluation of same, and responsible for administrative and supervisory duties in elementary, junior and senior high schools.

2. Technical director—In charge of standardization, purchase and mechanical upkeep of all visual aid equipment in classrooms and auditoriums and photographic laboratory production.

3. Teacher-research assistant—In charge of research and organization, repair and replacement of all pictures, charts, stillfilms and motion picture films.

4. Teacher-research assistant—In charge of research and organization, repair and replacement of slides, stereographs, exhibits, specimens and models.

5. Clerk—In charge of distribution, inspection of returned materials, filling orders requested by teachers and keeping distribution files for each type of visual aid with monthly reports of same.

6. Secretary—In charge of correspondence, overdue

Strongly Favor Pictures In Education

by

Marian Evans

Head of Visual
Education Department,
San Diego Schools

notices, requisitions, auditing and bookkeeping, rentals of projectors to out-of-school organizations, bulletins, catalogs, etc.

7. Film inspector, emergency delivery carrier and janitor (part time).

Surveys show that there should be more uniformity as to the basis for figuring annual visual education budgets. The most satisfactory method seems to be that of figuring a percentage basis of per pupil average daily attendance to cover all expenses except that of installation of equipment permanently placed in schools, which should be considered

a part of standard school furnishings. Such a rate may be established to parallel the amount allowed for books which, in most California cities, averages between 75c to $1.00 per A.D.A. for elementary school pupils and $2.00 to $6.00 per pupil in high schools. In establishing a department it would be economical to start with the minimum figure of the elementary A.D.A. and, as the demand and use for visual aids increases, adopt the high school figure.

We know that intelligent parents and citizens of the community are heartily in favor of visual instruction. In fact, in many school systems an inventory of visual education equipment shows that more than fifty per cent has been purchased from funds raised by Parent-Teacher groups or other organizations which expect School Boards to make visual aids available to their children.

Should you follow the teacher into the classroom you would see at least three types of pictures in use—Beautiful and appealing art creations, subject content pictures and original illustrations by students which give their own interpretations of the subject studied. In addition to books, you would also see stereographs, photographs, a box of lantern slides, a still film, motion picture film or collections of natural history specimens and industrial exhibits.

You may ask what will be the result of this visual education program?

Our answer is that we hope it will train the powers of observation, create worthy experiences, clarify thinking and invite expression in some form on the part of students. We anticipate that the boys and girls of today's school, who are learning to reason problems through to a successful conclusion, may be able to solve some of the economic and social problems which our generation has failed to meet. And we trust that these boys and girls, through visualization of life as it really exists, may be inspired to plan and create a more perfect material world for they will have vision and understand that creation is not a miracle of the dead past, but a wonderful drama of the living present which they themselves may help to create and improve.

16 mm. library and film inspecting room of San Diego schools.

The Ideal Baby Picture

IT'S a gem. . . an idea that is 100 per cent for the amateur . . . and we found it in a professional picture right in the theatre around the corner.

All of which makes us say again the theatre is the greatest school in the world for the amateur cinematographer. Follow your favorite cameraman as the movie fan follows his or her favorite star and you cannot help taking on some of his technique.

This picture we found was called "Baby Mine," a Warner Bros. Vitaphone release. It was about 800 ft. and if there was ever silent picture technique . . . it has it. It shows the day in a baby's life, from the time it awakes in the morning until night.

But the business that makes it so darn good is that you never see an adult, that is, not in his or her entirety, just their feet and hands. Here's the scenario of it as we remember the story.

The picture opens with a flash of the baby asleep in the crib, showing a bit of restlessness as though about to waken. You flash to a corner of the room and you see the dog sleeping. Back to the baby who stirs and opens its eyes. The dog rises to its fore-feet. Back to the baby who starts yawning; back to the dog who yawns. Then the dog goes to the side of the baby's crib when the baby starts crying. Next you see a pair of woman's slippers at the side of a bed. You see the feet coming from the bed and going into the slippers the feet walk to the ice-box. Then a lady's hand takes a bottle of milk from the ice-box. The hands prepare the milk for the baby.

Then there is a flash back to the crib. The baby still crying. The dog walking up to the crib. The hands with the bottle come into the camera's view as it shows the baby crying lustily. The nipple on the bottle is put in the baby's mouth. Slowly the baby stops crying and eagerly eats.

The picture then proceeds to go into the rest of the day of the baby's life. You see the hands take it from the crib. Lift it to a table. It is undressed for its bath. The parrot peaks out of the cage at the proceedings. The dog is at the lady's feet looking up. The baby is dressed, put back into the crib, given something with which to play. Later you see it being bundled into a baby buggy. You see the buggy out on the street, with the dog walking alongside of it. The buggy returns. The baby has its afternoon nap. Later you see a pair of man's feet come through the door. You see his hands pick the baby up. You see him trundle the baby on his knee . . . of course the bit of comedy of baby wetting his knee. Baby is prepared for bed.

While this is not all of the detail or all of the business . . . still it is the basis of the story. If you have a baby you'd like to picture, build your own scenario from this. The intriguing thing about the entire picture is that you never see the full adult, only the hands and feet as they minister to the baby.

If you haven't a dog or a parrot perhaps you have a cat and a canary or some other pet. Get them in the picture.

You can work out a mighty fine scenario around this thought that will make you feel proud of the picture you turn out. We cannot help but to again impress you with the fact that its whole magic is that the adults are never shown.

While we are on that subject there was a picture made recently here in Hollywood that has caused somewhat of a sensation. It also was a short subject. Its entire cost was $408.00, according to reports. A young newspaper man got the idea that like O. Henry maintained, there is a story in everyone who passes down the street. He imagined these stories and built his picture. It is called "Main Stem." See it. The $408.00 was spent mostly for raw stock to make the picture. He was a rather good promoter, talked his actors and technical help to go in with him on a co-operative basis. But the surprising thing is that it was all made out of doors.

When you see things in professional pictures that intrigue you . . . things that you would like to do in your pictures, ask us about them. Give us the name of the picture . . . the name of the cameraman and if possible we will have the cameraman who made the picture answer your question.

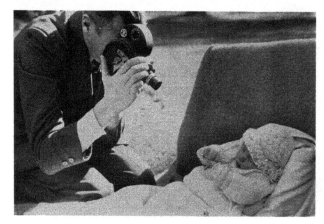

The best actor in the world is a baby. Read the story on this page . . . it's the finest idea for a baby picture we have ever heard.

and how to use them . . .

A 16 MM. PRODUCTION—from the reference library of THE AMERICAN SOCIETY OF CINEMATOGRAPHERS—"Camera Masters of the World." Photographed by Ned Van Buren, A.S.C., conceded the greatest authority on filters in the industry.

DEALERS—this subject shows just what the different filters will do—what effect they will give. It is used by the professional for this purpose. Now available to you—so that you may authoritatively demonstrate to the amateur the purpose of the different filters. Is accompanied by a written description for your use. It will prove an authoritative and beneficial sales help to you.

"FILTERS" is the first of a series of subjects to be released from the Reference Library of the American Society of Cinematographers. For full information, prices, etc., write

AMERICAN CINEMATOGRAPHER
6331 Hollywood Blvd. Hollywood, Calif.

Amateur Club Sells Picture

SENSING the wide spread interest in 16 mm. film for pictures of the complete Olympic Games, Eastman Kodak Stores, Inc. have secured the rights for the 1600 foot reel taken by members of the Los Angeles Amateur Cine Club, for world wide distribution. Dealers are now offering this outstanding movie complete as one unit or in separate reels of 400 feet each.

Members of the executive staff of the Olympiad committee were guests at the club's November meeting and expressed their appreciation of the picture as a difficult subject well covered.

The task of editing the 10,000 feet, taken by club members, and which included every major sport event from the Olympic torch ritual on the opening day, to the trumpet fanfare of the closing ceremony, has taken many weeks to complete. One member turned the entire third floor of his home into a veritable cutting room. After making a log of the entire footage, the many subjects were grouped into units. Track and field were assigned to one group, the marathon race to another; equestrian subjects were allocated into cross-country, dressage and jumps. Swimming races, rowing, boxing, the women's events, and atmosphere shots of close-ups of world famous athletes, ceremonies, etc. were also assigned. This system gave each committee many varied angles to select from, for special camera locations were granted photographers in frequent instances. Slow motion and telephoto shots were also inserted to advantage.

Included in the editing and titling committee were: Wayne H. Fisher, Colonel T. F. Cooke, Fred Champion, Church Anderson, Dr. L. Bailey, Tracy Hall, Dr. A. C. LaTouche and Dr. W. R. Maiden. Titles were written by F. B. Skeele and photographer by E. W. Walker.

Many requests are being received from clubs and organizations for a showing of the film which has captured not only all of the major Olympic events with thrills and spills, but portrays the beauty and atmosphere witnessed by over two million spectators.

Morey Dresses Up Spotlight

HAL MOREY, secretary of the Greenbrier Amateur Movie Club, shows that restless creative spirit in the November issue of their monthly periodical "Spotlight."

This latest issue comes out dolled up with a striking color, breezy with snappy news and well illustrated. The impression the "Spotlight" gives is that the Greenbrier club is an active, creative organization of enthusiastic members, each of whom will serve as assistant cameraman or star, if circumstances demand.

150,000 16 Projectors In Use In England

MR. ADRIEN BRUNEL, who has just completed a survey of the home movie market in England reveals the fact that there are now 150,000 users of home projectors in that country. Practically all are sub-standard, and it is estimated that after the Christmas sales this number will be increased to 200,000. Since the introduction of panchromatic negative for sub-standard camera users, the quality of home films has improved tremendously, this proving a great impetus to sales, Mr. Brunel states.

2

for the
PRICE OF ONE

de Brie Announces Silent Camera
Continued From Page 16

delicate Panchromatic and Super Sensitive emulsions.

The Super Parvo is claimed to be the smallest camera of 1000 ft. capacity yet made; the dimensions are 19½"x14" x10½"—roughly one-third of the size of the average soundproof blimp. In this restricted space are arranged the movement, the lens and viewfinder, the two magazines, the motor, and all the component parts completely enclosed in a sound-proof case. Only the lens-shade and matte box are mounted externally.

The materials used in the construction of the new camera have been selected with special reference to their sound-carrying characteristics as well as to their tensile and compressive strengths, etc. The gears, for example, are protected with a special noiseless material, as rigid as steel, but which suppresses the whistling sound generally caused by metal gears. The cutting of the gears has also been given special attention. The driving gears are hermetically sealed in an oil bath, and all other parts are efficiently lubricated by a direct tube system permitting very rapid servicing.

The mechanical parts of the Super Parvo are mounted in such a manner that no vibration can reach the casings, which is itself soundproof.

The motor is placed inside the camera, assuring absolute silence. The motor is instantly removable and completely interchangeable. The camera functions on a synchronous motor of 110 or 220 Volts A. C. or 110 Volts D.C., or on a battery-powered 24 Volt motor. The synchronous motors operate on either 40, 50 or 60 cycle Alternating Current.

The footage and frame meters and the tachometer are mounted at the rear of case, and countersunk under glass dials. They are indirectly illuminated, like the instruments on an automobile's dash.

The lens is protected by an optical glass, the surfaces of which are mathematically parallel, and which is so mounted as to be rigidly placed with these faces always perpendicular to the optical axis of the lens. This cover-glass is pivoted to swing horizontally out of the way when it is desired to have access to the lens for changing lenses or adjusting filters, etc., which are mounted within.

The lower sprocket is fitted with a special anti-buckling trip which is said to positively eliminate all mechanical troubles due to buckles.

The aperture is the latest reduced type for use with sound-on-film recording. The lens has been recentered to allow for the sound-track.

In the previous models of the de Brie Parvo, the shutter and lens-mount were entirely independent of the mechanism, being hung on the front part of the case. In the Super Parvo these parts are placed directly in front of the mechanism, and are pivoted so as to free the aperture for more conveniently loading the camera. Whereas this assembly, in the earlier models, pivoted around a horizontal axis, and swung upwards, it is now pivoted around a vertical axis, and swings horizontally sideways.

The shutter-aperture is adjustable, and there is an automatic fade, fading out in 4½ feet. It is also possible to make longer fades by hand. There is an automatic brake, by means of which the motor is disconnected and the movement stopped within two frames at the end of a fade-out. For making lap-dissolves, the camera, after making the first fade-out, can be reversed, when it will turn back 72 frames and automatically stop. When focusing during the making of such dissolves, the shutter automatically opens whenever the ground-glass is placed in the aperture for focusing.

The tripod designed for use with the Super Parvo is a tribute to the new camera's compactness and lightness. Equipped with a friction head and sliding legs of a new type, it is said to be exceedingly rigid and to weigh no more than 25 lbs. The camera fits onto the tripod-head by means of a dovetailed guide into which the camera slides and locks automatically. The vertical movement of the tilt-head is 45 degrees to each side. Both pan and tilt movements are controlled by friction-shafts, with adjustible tension.

For studio use, both electric and manually-operated rolling tripods are available. These latter are, by the way, capable of handling existing blimps; several of them are already in American studios.

Victor Supplying Powerful New 500 Watt Lamp

A NEW Mazda lamp of 500 watt-100 volt rating has just been perfected by the G. E. National Lamp Works. Although by far the most powerful T-10 size lamp yet developed, it is understood that dissipation of the heat generated by the 500 watt-100 volt lamp makes its use impractical except in a projector equipped with a highly efficient lamp house ventilating system.

So far, the only 16 mm. projector to be offered with this powerful new lighting equipment is the Victor Model 10FH

Premier Hi-Power. The Victor 10FH was first announced early in November and was originally equipped with the 400 watt-100 volt G. E. lamp. According to a statement issued by the Victor Animatograph Corporation, Davenport, Iowa, the Model 10FH, which has built-in lamp resistance in the base, will accommodate the new 500 watt lamp without alterations of any kind.

Inasmuch as it is said that the 500 watt lamp gives even too much light except for very large picture, long throws and daylight projection, Victor will continue to supply the 10FH with 400 watt lamps except when the 500 watt is specified. When equipped with 400 watt lamp the Premier Hi-Power Projector will be designated as the Victor Model 10FH-400, and when equipped with the 500 watt, as the Victor 10FH-500. The 10FH-500 will carry a list price of one dollar more than the 10FH-400.

The T-10 size 500 watt G. E. Mazda lamp should not be confused with the T-12 size 500 watt-110 to 120 volt lamp which has been on the market for some time. It is a much more powerful lamp than the latter.

An interesting feature of the G. E. Mazda 500 watt-100 volt lamp is its highly improved filament construction which, it is believed, will contribute greatly to its durability. It is of the 8-coil, biplane type which was originally introduced in the 400 watt lamp and makes possible an intensity of 16 mm. illumination that has heretofore been only a dream.

The 500 watt G. E. Mazda lamp will also be available with 110, 115, and 120 volt ratings for use in the Victor Model 10 Regular Projector. These lamps, of course, are not as powerful as the 100 volt lamp.

Mitchell Importing 16 MM Lenses

While the Mitchell Camera Corporation has been the American distributor of the professional Astro Lenses, only recently they have added the Astro 16 mm. lenses to their line. This series of lenses include 9 sizes and are corrected for color. The sizes would indicate that they are to be classed among the fast lenses available for 16 mm. use. They include 20 mm. F 1.5; 25 mm. F 1.5; 20 mm. F 1.8; 25 mm. F 1.8; 50 mm. F 2.7; 75 mm. F 2.7; 100 mm. F 5; 150 mm. F 5 and 200 mm. F 5.

Motion Pictures in Universities

Continued from Page 17

have a definite value in the home and primary school. The advertising that enters here is not as objectionable as the lack of requirements to fill a school program. These pictures made by the hundreds in these fields, for this reason, are not as widely used as they otherwise would be if the advice of educators familiar with school problems was solicited.

Just how seriously do the universities want films? Many of them have organized classes wherein the motion picture is entering, even to the point of teaching the dramatic technique as was first organized at the University of Southern California where motion picture appreciation has an academic rating. The University of Minnesota has inaugurated plans to teach all subjects even to geography and language when the films are available.

Northwestern is making surgical and medical pictures, one having been completed showing an operation. Yale is producing a series of pictures of historical events, as well as bringing together a library of all historical pictures or sequences of such pictures having value for the teaching of history. Chicago University has already completed two scientific talkies with plans formulated for a series along technical and biological lines.

While the move toward making pictures in the universities is not wide it is significant, and certainly shows a demand, or trend in this direction.

The few pictures that can be made with the limited facilities and lack of technical skill by the universities themselves are entirely inadequate to meet the demand.

In Europe, such aspects are more clearly understood and consequently more cooperation has been offered educators in this matter, with the result many suitable pictures are available. This country is far behind Europe in organizing its cultural film forces. Just as far behind in fact as Hollywood is advanced over foreign countries in production and mechanical skill. The trend toward the schools started abroad over ten years ago, and now the European educators have a praiseworthy system organized that supplies pictures conforming to their curricula.

Practically all the governments have departments set aside to care for this problem, some of them even subsidizing concerns for the actual making of pictures. In Japan, there is the "All Japan Association of Cine Education." Established within the French Ministry is the "Grand Council of Cinema," the cinema being represented in liaison with the other arts. "The Central Institute," in Berlin,

John F. Seitz' Wife Mourned

On Friday, January 6th, Mrs. Alyce Seitz, wife of John F. Seitz, former president of the American Society of Cinematographers, died of pneumonia.

Mrs. Seitz was well known and well liked in Hollywood social circles. She was noted throughout the motion picture industry for her many kind acts in befriending those in need. Mrs. Seitz was formerly Miss Alyce Creswell of St. Louis, Mo.

She leaves her husband, to whom she had been married about 20 years; a daughter, Margaret Alyce 2; a sister, Mrs. Fredrick Pendexter; her parents, two other sisters and a brother in St. Louis.

▲

has the right to certify and organize tax free showings. In Italy, the "Film Institute" is under government subsidy and distributes education films to all theatres. It is interesting to note that theatres in Italy are required to show at least ten minutes of educational films in every program.

In Russia, the industry is controlled by the state even to the point of training teachers in the technique of picture making so they may assist in the making of pictures. Great Britain has the "Commission of Educational and Cultural Films."

Probably the most valuable is the "International Institute of Cinema," organized as a branch of the activities of the League of Nations for the purpose of controlling and lending aid to the international aspect of cultural films. They as is generally known, publish a Journal in five languages and have been sanctioned by twenty-nine governments. Their offices are maintained in Rome by the Italian government.

The United States has government attention in the Department of Commerce, although nothing noteworthy has been done in organizing the cultural film forces. There is a definite move instigated by President Rufus B. von Klein Smid, of the University of Southern California, in collaboration with Mme Laura Drefus-Barney, the French woman distinguished in her activities along these lines abroad. She is a member of the Grand Committee of the Ministry of Education, in Paris, and also actively connected with the work of the League of Nations in the problems of International Education.

Charles Lang, A.S.C., Gets New Contract

Coincident with the release of his latest picture, "A Farewell to Arms," Charles Lang, A.S.C., has signed a new long-term contract with Paramount. He has been assigned to the camera on Chevalier's "Bed Time Story."

Tetzlaff to Reliance Productions

Teddy Tetzlaff, hitherto with Columbia, is reported to have been signed by the Edward Small Reliance Pictures Corp. to photograph the productions which that firm will release through United Artists. The first of these will probably be "I Cover the Waterfront."

Dan Clark, A.S.C. to MGM

Daniel B. Clark, past President of the A.S.C., spent Christmas Eve finishing the camerawork on his 83rd picture with Tom Mix. With Mix' retirement, Clark goes to Metro-Goldwyn-Mayer.

What is the intrinsic value of the motion picture in this field? This can well be shown by the incident of the recent premiere showing of two scientific talkies by the University of Chicago. This exhibition required twenty minutes on the screen and covered subjects with more dispatch and effectiveness than could be explained in five hours in both the laboratory and lecture room.

Although it is entering the educational fields, it will never replace the teacher, but merely serve as a tool, to make the teachers more effective and to expedite their teachings. It will fluently explain and strengthen their approach. What student will not lastingly remember, for example, if he would see the "Molecular Theory of Matter," as made and shown in the recent screening at the Chicago University? Here the motion of moleculars is picturized, and the whole is explained by introducing them as characters in a motion picture. Few of us more than casually remember the theory, but all will remember the painful explaining of it by our teachers using hands, words and chalks in the past.

It is not intended that pictures should entertain as they educate but it is the utilization of a tool of this age that gives efficiently more than the older method of word of mouth research. In order to keep up with the specialization and "Technocrat" machines, education must be served in great gulps. Now forty students using motion pictures may see an operation in a small fraction of the time required when only four students could hang over the surgeon in the older way.

Warrenton Shoots Songbird

Gilbert Warrenton, A.S.C., has just completed the photography of "Hello Everybody," starring Kate Smith, radio singer.

J. A. Dubray, A. S. C., Authors
Book on Cinematography

JOSEPH A. Dubray in collaboration with James R. Cameron has authored a book for the consumption of the amateur cinematographer under the title of "Cinematography and Talkies."

Dubray, acknowledged one of the best informed men not only in Hollywood, but in the entire history, gave liberally of his store of technical knowledge to this opus.

In its opening chapters the book touches upon the historical side of photography, its expansion and early experiments.

Launching into the more minute technical phases it tells graphically about light, its values, its use, and it is told in such a clear and comprehensive manner that the amateur will find it a delight to read.

Those paragraphs on lens exposures, lighting indoor movies, color filters, reflectors and other phases of picture making that touch upon the everyday activity of the amateur will give him much information for which he has been seeking.

The book also launches into sound and especially as it is applied to 16 mm. film. This may prove valuable with the present tendency of the industry in this direction.

Gilks Photographs Vanderbilt Cruise

At the charity showing in New York of the Wm. K. Vanderbilt picture "Over The Seven Seas," which was photographed by Al Gilks, A.S.C., much praise was accorded not only the production but the photographic effects secured by Gilks. Considerable of this picture was shot in color.

Gilks accompanied Vanderbilt on a world cruise which took them over 29,000 miles. During this trip approximately 40,000 feet of film was exposed. From this negative Vanderbilt and Gilks cut the picture to its present length.

While the production was not made for commercial purposes, still it was commented upon by critics not only of the daily New York papers, but also by the trade press as an exceptional travel picture, that reflected great credit upon Vanderbilt as a producer and director and upon Gilks as a cameraman.

The unusual pictorial beauty of both the black and white shots as well as the color sequences of the South Sea Islands and the Dutch East Indian Islands as well as the other out of way ports the Commodore Vanderbilt "Alva" touched were highly praised.

Sixteen All the Way

New type 16 mm. "magazine camera" will be announced shortly. It is stated the new camera will not only use 16 mm. pictures as well. Following the popularity of the magazine type of camera for travelers it is expected this type of quick loading camera will become increasingly popular.

♦

Ralke Opens Branch

A Pacific Coast branch has been established by the Victor Animatograph Company under the direction of C. H. Ralke in the Quimby Building, Los Angeles. Ralke's many years' experience in the picture industry and especially in the amateur field qualifies him admirably for this position.

Bennett Buys Movie Business

THE retail section of the Hollywood Film Enterprises, has been taken over by Gordon B. Bennett who is now operating it under the name of Hollywood Movie Supply.

Mr Bennett has been in the motion picture business for more than 15 years. He is thoroughly conversant with every phase of the industry and since he entered in the 16 mm. field has been recognized as one of the outstanding authorities among the amateurs on matters of amateur equipment.

Henry Sharp on "The Good Thing"

· Following the completion of "The Devil is Driving," made by Charles Rogers Productions for Paramount release, Henry Sharp, A.S.C., has been signed by Paramount to photograph "The Good Thing" under the direction of Erle Kenton.

George Barnes Weds

George S. Barnes, Fox cinematographer, and Joan Blondell, Warner Bros.-First National star, were married in Phoenix, Arizona January fourth. They continued East for a honeymoon in New York.

Charles Clarke, A.S.C. to Metro

Following the completion of "Hot Pepper" for Fox, Charles G. Clarke, A.S.C. has received an assignment at the Metro-Goldwyn-Mayer studio.

Erratum

In our last issue, the photograph showing Karl Struss, A.S.C., presenting the 1932 Academy Award for Cinematography to Lee Garmes, was incorrectly captioned in that it was stated that Mr. Struss had won the Award two years previously. Mr. Struss actually had the distinction of winning, with Charles Rosher, A.S.C., the first Academy Award, in 1928. The 1930 Award was won by Joseph Rucker and Willard van der Veer, for "With Byrd at the South Pole." Our apologies to all concerned.

Making a Prize Picture
Continued from Page 29

box in her mouth!

There were other minor incidents which served to slow up the work. One youngster opened the side of our camera to inspect the film we had just taken. Our hero lost his special sweater, the only one like it in camp, while another leading character had his hair cut short before we were through with his scenes.

Such obstacles are common to any amateur production, but rather than lead to disaster, they often result in a finer piece of work. The attempts to remedy the defects with retakes, or patch up the discrepancies with additional scenes, frequently lead to results better than the original.

The end of camp found us with 1400 feet of film which had to be arranged, cut, and rearranged until all the "dead ends" of scenes were removed. Persistent re-editing was necessary in order to have the action flow smoothly through the various sequences. Even then, flaws in the continuity were discovered where the need for explanatory titles was

indicated, but here that useful device of cinematics, photomontage, came to the rescue. A few disconnected but related scenes can tell more story than dozens of long-winded explanatory titles.

The final editing gave us about 1,000 feet of picture, three reels. The four hundred feet of waste was due to some of the incidents mentioned. There were some retakes in the second sequence where the boys are trying to think of a story, made necessary when the camera was opened by an inquisitive youth. Again, in the sequence where our hero has his little soliloquy with the makeshift camera, we had one or two retakes on the book on motion picture direction to insert. The balance of waste film was composed of unsuccessful or unnecessary scenes in the more difficult sequences with the dog. We seldom had two takes of the same scene, unless, when photographed, the action did not go according to rehearsal. Usually the sequence would be rehearsed two or three times until we were convinced that the performance was what we wanted and then it would be photographed.

The writers were truly surprised and very happy to learn that "Tarzan Jr." attained such recognition, especially since no effort had been made to inject any of the modernistic tricks and trends of present-day amateur cinematography. Perhaps the simple straightforward photoplay stressing story value above atmosphere is still the ideal goal for an amateur group. The amateur, unhampered by commercial ties, free to do as he pleases without regard for the monetary returns, has many advantages over the professional producer. It may even be that in the future he will excel in cinematographic expression in spite of his limited facilities.

Explaining the "Gamma"
Continued from Page 20

scales at which the straight line crosses gives the numerical value of gamma. This gammeter is a mathematical computation worked out in exactly the same manner as was described above. Sensitometric practice, therefore, makes use of such transparent scales as shown in Figure 20. They are usually made on a sheet of cut film.

In the next article we shall consider specifically the relationship existing between gamma and contrast.

New Portable Sound
System Introduced

A NEW portable sound system, employing the twin-film system and recording by means of · the familiar glow-lamp has lately been announced by the Cinema Sound Equipment Company of Hollywood. According to Capt. Ralph G. Fear, who is the consulting engineer in charge of design and manufacturing for the new firm, the new Cinema Portable Recorder consists of a three-stage amplifier, an efficient and rugged recording head, and two sets of batteries to supply the current for the dual-powered circuit.

The amplifier is stated to be overpowered, so that perfect amplification may be had without distortion. Provision is made for mixing the signals from two microphones. The microphones are of the condenser type, with two stages of amplification, and built into the standard bullet-type case. The microphones may be used on the stands regularly supplied with the outfit, or used on overhead booms or cables. The amplifier is, according to Capt. Fear, built into a neat, suitcase-type carrier, at the top of which is the conventional mixing-panel, with the necessary dials, meters, etc. This case is so designed that it may be set on top of the amplifier battery case when in use. All of the connections are alleged to be of the heavy-duty screw type, and are waterproof.

The recording head itself is claimed by Capt. Fear to embody numerous exclusive features for which he has applied for patents. According to Capt. Fear, the head is of the double-sprocket type, with an optical recording slit. A new type of mechanical filter fitted with what Capt. Fear has termed a "filter retard" is used. This "filter retard" is held to positively eliminate unevenness or "wow-wows" in recording. The head is driven by a Westinghouse A.C.-D.C. Selsyn type interlock motor of the same type as that used on the camera. A governor-type speed control is available if desired. The driving gears are made in the firm's own plant, and are said to be of the highest precision workmanship. Both a tachometer and a Veeder footage-counter are supplied, and placed at the rear of the head, near the glow-tube mounting.

Two battery cases are supplied, one case containing the batteries which power the driving motors, and the other those which power the actual recording circuits. According to the designers, this feature minimizes the trouble otherwise occurring when the batteries become depleted. Battery eliminators can, it is stated, be had for use wherever alternating current is available.

Dr. Meyer Visits AGFA-Ansco Factory

Dr. Herbert Meyer, A.S.C., left recently for his annual visit to New York, where he will confer with officials of the Agfa-Ansco Corporation and visit their plant at Binghamton, N. Y. He will be in the east approximately a month.

Projection Keystoning

Continued from Page 9

aperture plates, to be used as indicated in the last column of Table 1. The percentage "loss" indicated in Fig. 4 is the amount by which the aperture plate is reduced at the top and also therefore, the loss in the width at the bottom of the screen picture.

As mentioned previously, it is felt that correction for keystoning will be satisfactory, provided the cameraman does not have long vertical lines or columns at the extreme sides of the picture, but that further corrections will introduce complications and errors more serious than those being compensated for.

The foregoing covers some of the reasons why the cameraman must interest himself in modifications of standard practice which may be made by the projectionist. The adoption of the standard camera and projector aperture has overcome many of the difficulties occasioned by the use of sound on film. It remains to follow this up by making sure that modifications of the new standard projector aperture do not correct one evil and introduce others

DeVinna Radios from Alaska

Clyde DeVinna has finally been discovered. The ether waves on Christmas morn brought about his discovery. Clyde hied himself to Alaska a short time ago to be the first one to greet Santa Claus. No wonder Santa was late in these parts.

Glenn Kershner Returns from South Seas

On his return from the South Seas, Glenn Kershner, A.S.C., found a lot of cinematographic competition on ship. More than a dozen 16 mm. cameras were in evidence doing duty for their owners. When it was discovered that Kershner was a professional cameraman, he practically had to institute a class in cinematography on board ship every day.

Directory of Dealers
Handling
The American Cinematographer

ARIZONA
Tucson: William M. Dennis, 22 United Bank Bldg.

ARKANSAS
Judsonia: Lee's Novelty House.

CALIFORNIA
Fresno: Potter Drug Co., 1112 Fulton Ave.
Glendale: Kug Art Photo Service, 507 West Colorado Blvd.
Hollywood: Bell & Howell Co., 716 North La-Brea Ave.
Hollywood Camera Exchange, Ltd., 1600 N. Cahuenga Blvd.
Hollywood Citizen, 6366 Hollywood Blvd.
Hollywood Movie Supply Co., 6038 Sunset Blvd.
J. V. Merchant, 6331 Hollywood Blvd.
Universal News Agency, 1655 Las Palmas.
Los Angeles: California Camera Hospital, 321 O. T. Johnson Bldg.
Eastman Kodak Stores, Inc., 643 So. Hill Street.
Educa ona Projecto Film Co., 317 N. Fairfax. ti l
T. Iwata Art Store, 256 East First St.
Lehnkering Pharmacy, 1501 N. Western Ave.
B. B. Nichols, 731 South Hope St.
Tappenbeck & Culver, 10958 Weyburn Ave., Westwood Village.
North Hollywood: Studio City Pharmacy, 12051 Ventura Blvd.
Pasadena: The Flag Studio, 59 East Colorado St.
Richard Fromme, 965 S. Fair Oaks.
A. C. Vroman, 329 East Colorado St.
San Diego: Harold E. Lutes, 958 Fifth St.
San Francisco: Eastman Kodak Stores, Inc., 216 Post St.
Hirsch & Kaye, 239 Grant Ave.
San Francisco Camera Exchange, 88 Third St.
Schwabacher-Frey Stationary Co., 735 Market St.
Sherman, Clay & Co., Kearny & Sutter Sts.
Santa Barbara: J. Walter Collinge, 1127 State St.
Stockton: The Holden Drug Co., Weber Ave. & Sutter St.
Logan Studios, 20 N. San Joaquin St.

COLORADO
Denver: Eastman Kodak Stores, Inc., 626 Sixteenth St.

CONNECTICUT
Bridgeport: Harvey & Lewis Co., 1148 Main St.
Hartford: Watkins Bros., 241 Asylum St.

ILLINOIS
Chicago: Almer, Coe & Co., 105 N. Wabash Ave.
Associated Film Libraries, Inc., Suite 224, 190 N. State St.
Bass Camera Co., 179 West Madison St.
Central Camera Co., 230 S. Wabash Ave.
Eastman Kodak Stores, Inc., 133 N. Wabash Ave.

CAMERA CRAFT

A MONTHLY MAGAZINE OF PHOTOGRAPHY

Camera Craft gathers beauty, facts, fundamentals and all sorts of interesting information from all over the world to keep its readers fully informed. It has a Cine Department that makes a specialty of new wrinkles and information not to be found elsewhere.

$2.00 per Year
Sample copy on request

CAMERA CRAFT
PUBLISHING COMPANY
703 Market Street
San Francisco, California

Directory of Dealers
Continued

Fair, The, Camera Dept., 7th Floor, State-Adams-Dearborn Sts.
Springfield: Camera Shop, The, 320 S. Fifth St.
IOWA
Sioux City: Lynn's Photo Finishing, Inc., 419 Pierce St.
KANSAS
Wichita: Jack Lewis Film Service, 329 Sedgwick Building.
LOUISIANA
Monroe: Griffin Studios, P. O. Box 681.
MARYLAND
Baltimore: Eastman Kodak Stores, Inc., 309 N. Charles St.
MASSACHUSETTS
Boston: Eastman Kodak Stores, Inc., 38 Bromfield St.
Iver Johnson Sporting Goods Co., 155 Washington St.
Pathescope Co. of the N. E. Inc., 438 Stuart St.
Pinkham & Smith Co., 15 Bromfield St.
Braintree: Alves Photo Shop, 349 Washington St.
Cambridge: E. M. F. Electrical Supply Co., 430 Massachusetts Ave.
Springfield: Harvey & Lewis Co., 1503 Main St.
Worcester: Harvey & Lewis Co., 513 Main St.
MICHIGAN
Detroit: Crowley, Milner & Co.
Detroit Camera Shop, 424 Grand River W.
Eastman Kodak Stores, Inc., 1235 Washington Blvd.
Grand Rapids: Camera Shop Stores, Inc., 56 Monroe Ave.
Photo Service Shop, 44 Monroe Ave.
MINNESOTA
LeRoy: Ivan E. Meyers, Home Movie Service, 215 W. Main St.
Minneapolis: Eastman Kodak Stores, 112-116 So. Fifth St.
National Camera Exchange, 5 South Fifth St.
MISSOURI
St. Louis: Eastman Kodak Stores, Inc., 1009 Olive St.
MONTANA
Bozeman: Alexander Art Co.
NEBRASKA
Omaha: J. G. Kretschmer & Co., 1617 Harney St.
NEW JERSEY
East Orange: Edmund J. Farlie Jr., 45 N. 19th St.
Union City: Heraco Exchange, Inc., 611 Bergenline Ave.
West New York: Rembrandt Studios, Inc., 526A Bergenline Ave.
NEW YORK
Binghamton: A. S. Bump Co., Inc., 180 Washington St.
Brooklyn: Geo. J. McFadden Inc., 202 Flatbush Ave.
Buffalo: Buffalo Photo Material Co., 37 Niagara St.
New York City: Wm. C. Cullen, 12 Maiden Lane
Eastman Kodak Stores, Inc., 356 Madison Ave. at 45th St.
Gillette Camera Stores, Inc., 117 Park Ave.
Herbert & Huesgen Co., 18 E. 42nd St.
Mogull Bros. Electric Corp'n., 1944 Boston Road, Bronx.
New York Camera Exchange, 109 Fulton St.

Times Building News Stand, Inc., Times Building.
Willoughby's, 110-112-114 West 32nd St.
Rochester: Marks & Fuller, Inc., 36 East Ave.
Sibley, Lindsay & Curr Co.
Smith, Surrey, Inc., 129 Clinton Ave., South.
Schenectady: J. T. & D. B. Lyon, 236 State St.
Syracuse: Francis Hendricks Co., 339 So. Warren St.
Utica: Edwin A. Hahn, 223-225 Columbia St.
OHIO
Cincinnati: Eastman Kodak Stores, Inc., 27 West Fourth St.
Huber Art Co., 124 Seventh St., W.
Salem: Butcher's Studio, 166 South Broadway.
Toledo: Gross Photo Supply Co., 325 Superior St.
OREGON
Pendleton: J. T. Snelson, 608 Gardner St.
Portland: Eastman Kodak Stores, Inc., 345 Washington St.
PENNSYLVANIA
Erie: Kelly Studios, 1026-28 Peach St.
Philadelphia: Klein & Goodman, 18 South Tenth St.
MacCallum Stores, 1600 Sansom St.
Pittsburgh: Eastman Kodak Stores, Inc., 606 Wood St.
Wilkes Barre: Ralph DeWitt, 2 South River St.
VERMONT
Burlington: G. W. La Pierre's, 71 Church St.
WASHINGTON
Seattle: Anderson Supply Co., 111 Cherry St.
WISCONSIN
Milwaukee: Eastman Kodak Stores, Inc., 737 N. Milwaukee St.
Photoart House, The, 226 West Wells St.
Phillips: Jakoubeks', 132 N. Lake Ave.
AUSTRALIA
Melbourne: McGills Agency, 179-218 Elizabeth St.
CHINA
Canton: International Book Co., 269 North Wing Hon Road.
HAWAII
Honolulu: Eastman Kodak Stores, 1059 Fort St.
INDIA
Bombay: Continental Photo Stores, 255 Hornby Road.
P. C. Eranee Sons, Albert Bldgs., Hornby Road.
Calcutta: Photographic Stores & Agency Co., 154 Dhuramtolla St.
M. L. Shaw, 5/1 Dhuramtolla St.
Lucknow: Lucknow Commercial Co., 25 Aminabad Park.

Al Gilks on High Seas
Not for pleasure, but to secure some important sequences for a Sea Story which Director Shirley Burden is shooting for RKO, Al Gilks has been spending better than a month on the high seas off the Coast encountering some of the most treacherous weather the seamen in these parts have known for many years.

Classified Advertising

Rates: Four cents a word. Minimum charge, one dollar per insertion.

SITUATION WANTED—Recent E. E. Graduate wants apprenticeship with an M.P.E., Cinematographer, Sound Man or what have you, in order to gain experience in the industry. Algird Steponaitis, 18 Monroe Street, Mount Vernon, New York.

FOR RENT—MISCELLANEOUS

FOR RENT—Mitchell Motor, 1000 Ft. Mitchell Magazines. J. R. Lockwood, Glendale. Douglas 3361 W.

FOR RENT—Mitchell high speed gear box complete. Pliny Horne, 1318 N. Stanley. HO-7682 or HO-9431.

● *You want The Cinematographic Annual*

FOR SALE OR RENT

FOR SALE OR RENT—Mitchell and Bell & Howell silenced cameras, follow focus Pan lenses, free head, corrected new aperture. Akeley, DeBrie, Pathe, Universal, Prevost, Willart, DeVry, Eyemo, Sept, Leica. Motors, Printers, lighting equipment. Also every variety of 16mm and still cameras and projectors. Everything photographic bought, sold, rented and repaired. Send for our bargain catalogue. Open 8 A.M. to 10 P.M. Hollywood Camera Exchange, 1600 Cahuenga Blvd. Phone: GLadstone 2507; HOllywood 9431. Cable address Hocamex.

WANTED

WANTED—A Portable single system Sound-on-film Camera recording outfit Complete. State Lowest price. George Drivas, Cor. 6th Ave. & Main St., Carbondale, Penna.

WANTED—Will trade Prevost news camera for Cine Kodak hand crank or Filmo, and pay cash difference for Eyemo Camera. Jack Campbell, 306 So. Lisbon Ave., Tampa, Florida.

SHOTGUNS, Target Pistols, Rifles and other good firearms may be traded in at liberal allowances on any photographic equipment, movie or still, including Bell & Howell Eyemos and Filmos, Eastman, Victor, Leitz, Zeiss, Stewart Warner and other leading makes. NATIONAL CAMERA EXCHANGE, 5 South 5th St., Minneapolis, Minn.

FOR SALE—CAMERAS

FOR SALE—Universal Camera (Dissolve) Rigid Sound Blimp, Tripod, 3 lenses, 5 magazines, Matte Box. Good condition. Best offer accepted. C. Nelson, 164-12 110th Road, Jamaica, N. Y.

FOR SALE—New Model 5 Victor Camera complete with 3 Hugo Meyer lens, 1". F.2.A; 3" F.3; 4" F.4 and Case. Regular Price $322.00. Now $198.00. Hollywood Movie Supply Co., 6058 Sunset Blvd., Hollywood, Calif. Phone HE 7121.

FOR SALE—Akeley Camera No. 230. Tripod with Mitchell legs, baby tripod, high hat, adjustable shutter, 6 magazines; 2-2in. F 2.7, 4 in. F 2.3, 6 in. F 2.7. 12 in. F 5.6 lenses with finder lenses. Motor attachment, carrying cases, first class condition. J. P. Muller, 7825 Hampson St., New Orleans, La.

You want The Cinematographic Annual ●

FOR SALE—MISCELLANEOUS

FOR SALE—MAKE YOUR CAMERA PAY. Get into print. Stamp brings "Bulletin 10-AC" listing pictures wanted hundred magazines, newspapers, photographic contests, etc. AUTHORS, Drawer 1916, Baltimore, Maryland.

FOR SALE—1 - 75 mm. Cook Lens F.2 with Mitchell mount complete. $100.00. J. R. Lockwood, 523 N. Orange St., Glendale, Calif. Phone Douglas 3361 W.

FOR SALE—Six 400 Ft. Mitchell Magazines cheap. J. R. Lockwood, 523 N. Orange St., Glendale, Calif.

544 pages of valuable information. ●

ON THE JOB WITH
CAMERA AND SOUND MEN

PRODUCTION	DIRECTOR	CAMERA	SOUND
COLUMBIA STUDIO—Emil Oster, Camera Executive.			
Fever	CLARENCE BADGER	BEN CLINE	EDWARD BERNDTS
Parole Girl	EDWARD CLINE	JOSEPH AUGUST	GLENN RONNINGER
FOX STUDIO—Godfrey Fisher, Camera Executive			
Road to Heaven	JOHN FRANCIS DILLON	L. WM. O'CONNELL, A.S.C.	EUGENE GROSSMAN
METRO-GOLDWYN-MAYER STUDIO—John Arnold, A.S.C., Camera Executive			
Pig Boats	JACK CONWAY	HAL ROSSON, A.S.C.	RALPH SHUGART
The White Sister	VICTOR FLEMING	WILLIAM DANIELS, A.S.C.	G. A. BURNS
Turn About	HOWARD HAWKS	OLIVER MARSH, A.S.C.	A. MACDONALD
The Lady	CHARLES BRABIN	MERRITT P. GERSTAD	PAUL NEAL
Clear All Wires	GEORGE HILL	PERCY HILBURN	ROBERT SHIRLEY
Happy Days	EDWARD SEDGEWICK	HAROLD WENSTROM, A.S.C.	C. WALLACE
Eskimo (On location in Alaska)	W. S. VAN DYKE	CLYDE DE VINNA, A.S.C.	CARROLL PRATT
PARAMOUNT STUDIO—Virgil Miller, Camera Executive			
From Hell to Heaven	ERLE KENTON	HENRY SHARP, A.S.C.	HAROLD LEWIS
Crime of the Century	WILLIAM BEAUDINE	DAVID ABEL, A.S.C.	P. G. WISDOM
Woman Accused	PAUL SLOANE	KARL STRUSS, A.S.C.	EARL HEYMANN
Murders in the Zoo	EDWARD SUTHERLAND	ERNEST HALLER, A.S.C.	M. M. PAGGI
A Lady's Profession	NORMAN Z. McLEOD	GILBERT WARRENTON, A.S.C.	H. M. LINDGREN
CHARLES ROGERS PRODUCTIONS			
Strictly Personal	RALPH MURPHY	FAXON DEAN-MILTON KRASNER	FRANK GOODWIN
R-K-O STUDIO—William Eglinton, Camera Executive			
Our Betters	GEORGE CUKOR	CHARLES ROSHER, A.S.C.	GEORGE D. ELLIS
Sweepings	JOHN CROMWELL	EDWARD CRONJAGER	CLEM PORTMAN
The Great Desire	DOROTHY ARZNER	BERT GLENNON	HUGH McDOWELL
The Great Jasper	J. WALTER REUBEN	LEO TOVER	JOHN TRIBBY
Topaze	HARRY D'ARRAST	LUCIEN ANDRIOT	DENZIL A. CUTLER
Pigmy	SHIRLEY BURDEN	A. L. GILKS, A.S.C.	
King Kong	MERIAN C. COOPER	EDWARD LINDEN	EARL WALCOTT
UNIVERSAL STUDIO—Charles Glouner, Camera Executive			
The Big Cage	KURT NEUMANN	GEORGE ROBINSON	WM. HEDGECOCK
UNITED ARTISTS STUDIO—Harry Abrams, Camera Executive			
Secrets	FRANK BORZAGE	RAY JUNE, A.S.C.	FRANK MAHER
The Masquerader	RICHARD WALLACE	GREGG TOLAND	OSCAR LANGERSTROM
WARNER BROS.-FIRST NATIONAL STUDIO, Milton Cohen, Camera Executive			
Keyhole	MICHAEL CURTIZ	BARNEY McGILL	C. A. RIGG
Elmer the Great	MERVYN LE ROY	ARTHUR TODD	CHARLES ALTHOUSE
Baby Face	AL GREENE	JAMES VAN TREES, A.S.C.	OLIVER GARRETSON
Picture Snatcher	LLOYD BACON	SALVADORE POLITO, A.S.C.	E. A. BROWN
Central Airport	WILLIAM WELLMAN	SID HICKOX	ROBERT B. LEE
Silk Express	RAY ENRIGHT	CAETANO GAUDIO, A.S.C.	DAVID FORREST

You supply the artistic sense . . .

. . . We'll supply the film to express it. In Eastman Super-Sensitive "Pan" we can offer you the versatility you want for every situation . . . the speed you need for all kinds of light . . . the uniformity that is indispensable to complete confidence in any product. And in the gray, anti-glare backing now obtainable with this film Eastman scientists have contributed one more quality to help you carry out your photographic ideas literally and without compromise.

J. E. BRULATOUR, INC.
New York Chicago Hollywood

WE NOW offer an adaptor for the MITCHELL ERECT IMAGE VIEW FINDER which will change the standard finder to a 25mm finder.

This 25mm adaptor can be fitted to your present finder and the mounting is so arranged that the adaptor can be quickly removed, when the wide angle is not desired, and the finder used in its standard form.

Orders for these adaptors will be accepted for delivery in three weeks.

MITCHELL CAMERA CORPORATION

665 North Robertson Boulevard, West Hollywood, California
CABLE ADDRESS: "MITCAMCO" :: :: TELEPHONE OXford 1051